ZEN DOODLE UNLEASHED

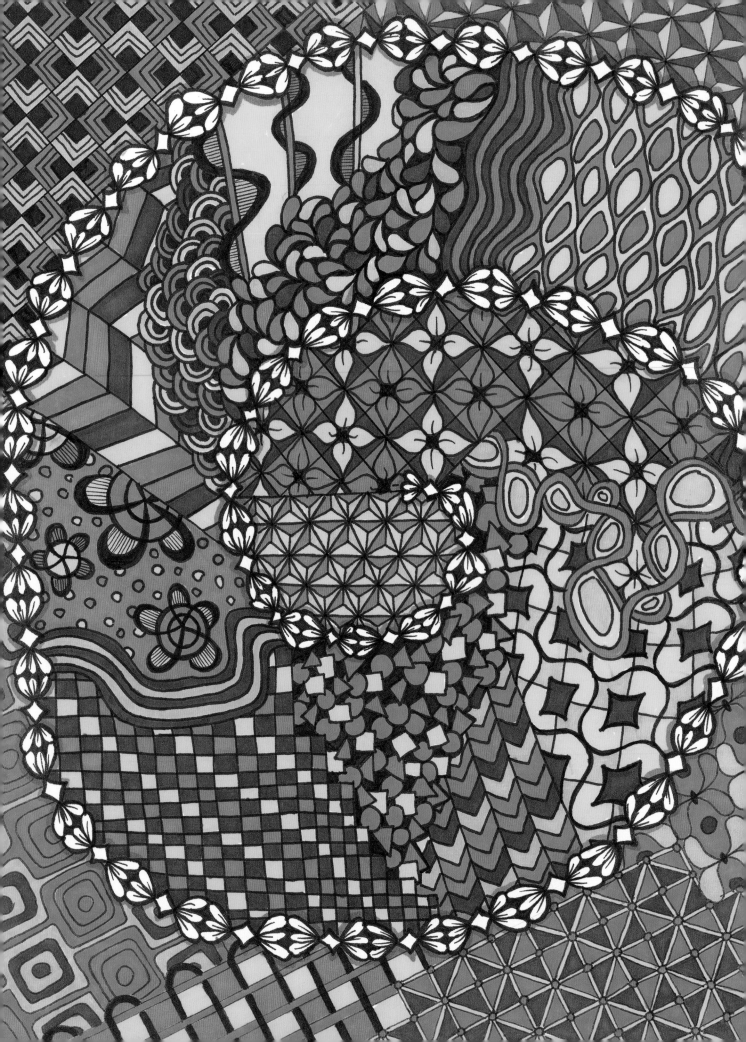

Zen Doodle Unleashed

Freeform Tangle Art You Can Draw and Color

Tiffany Lovering

NORTH LIGHT BOOKS
CINCINNATI, OHIO
CreateMixedMedia.com

CONTENTS

INTRODUCTION

Freeform tangling is a type of abstract art that uses fine-tipped pens to fill the page with repeating patterns that appear to build off each other. Color and shading can be added for a beautifully finished look.

A lot of art forms include the use of repeating patterns; the most notable is Zentangle® created by Rick Roberts and Maria Thomas. What sets freeform tangling apart is that it is much less restrictive than other art forms. There is no "string" or boundary to keep your patterns in. Instead, you create freeform patterns that build off each other until they fill the page.

The best part about freeform tangling is that anyone can do it. Even if you have unsteady hands, it is simply a matter of making the patterns and different types of strokes work for you. You don't even need to have any natural artistic talent to get started with freeform tangles. I have never been particularly great at drawing, but I always had the desire to create. I combined that desire with practice and determination, discovering freeform tangle art along the way and developing my abilities to what they are today. You can actually see the progress of my artistic journey on my YouTube channel. The art I created in my first videos is quite basic compared to what I do today. Artistic talent can be developed as long as you have the passion within you to do so.

As you work through the book and practice mastering the different patterns and drawings, there are four things you should always keep in mind to be successful: patience, practice, persistence and personality.

Patience is important because it may take awhile to grasp certain patterns. Don't feel discouraged if a pattern doesn't come naturally to you. If you start to feel frustrated with a pattern or drawing, set it aside and come back to it later. Freeform tangling is a relaxing and fun craft, and it's just not possible to be relaxed if you are feeling frustrated. It's important to remain patient as you are learning.

Practice . . . *a lot*. As with many things in life, your success is directly connected to the amount of time you spend practicing. Fit some practice time into your day any way you can. Keep a small notebook on hand as well as at home so you can practice patterns in your downtime, whether you're on hold during a phone call or watching TV or in the waiting room of your doctor's office. Once you have learned a handful of patterns, creating a freeform tangle won't take your full attention.

Persistence is also a major key to freeform tangles. As important as it is to put aside a drawing or pattern that frustrates you, it is equally or more important that you go back to whatever is frustrating you. Keep trying until you figure out how to do what you're trying to do. Eventually you will get it, and when you do, you will feel a well-deserved sense of accomplishment.

Personality is your own twist on freeform tangles. If you don't like the way a pattern looks but have an idea on how to change it, always go with your idea. It's natural to feel inspired by tangle drawings by other artists, but don't compare your work to the work of others. You should only compare your work to your own work. Let your own style shine. Spend your practice time developing your own style so your freeform tangles feature your unique personality.

I encourage you to join my Facebook page to share your artwork and ask any questions you may have about freeform tangles. I'm always available and would love to hear from you! Enjoy!

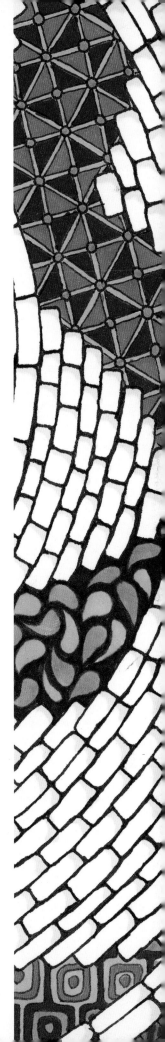

1

TOOLS & MATERIALS

Freeform tangles can be created with any art materials. This is something I can't stress enough. You don't need to go out and purchase new supplies—it's all about what feels most comfortable for you. You may also be aware of some tools commonly used in the tangle art world, but restricting yourself to such a list can potentially stunt the creative process.

No matter what supplies you choose to create your art, always experiment. Try out different strokes and techniques with each tool and material. Sometimes you can achieve a better result simply by switching the type of paper or brand of technical pen. Although you may not use all of the tools together in one piece of art, it is a good idea to have many on hand just in case you decide your drawing would look better with color, shading, circles created with a compass or straight lines drawn with a ruler. Let the pure freedom of making freeform tangle art take over, and allow the creativity to flow onto the page!

DRAWING TOOLS

There are many drawing tools to choose from and it may take some time to find your favorites. When Once I discovered my preferred set of tools, I created a "quick kit" in a shoebox so I'd have my supplies readily available when I had the urge to create a tangle. I highly recommend creating your own quick kit. This list of drawing tools is a good resource to turn to as you continue to try new materials.

Paper and Cardstock

It goes without saying that you need something to draw on, but with so many options, what should you choose? The main thing to consider is the texture of the paper. A smoother surface will allow you to create clean, crisp strokes with little effort.

The best choice for freeform tangling is 110-lb. (230gsm) cardstock. It is a medium-weight paper with a smooth surface that is ideal for drawing with technical pens, shading with pencil and blending with pastels. The cardstock is also thick enough to use permanent markers with little to no bleeding or feathering. Bleeding is how much of the color shows on the opposite side of the paper. Feathering refers to how much the color spreads out on the page when applied.

If you have trouble finding 110-lb. (230gsm) cardstock, 100-lb. (210gsm) bristol paper is the next best option. It is similar to cardstock, slightly smoother, but also a bit more expensive.

A thinner option is 65-lb. (135gsm) cardstock. You must be careful using this paper because permanent markers will feather, meaning you will need to work faster and make sure the markers don't sit in one space for too long.

If you plan to use watercolor on any part of your drawing, choose a high-quality, hot-pressed watercolor paper. Hot-pressed paper is smooth yet porous, so it reacts well to water and watercolor.

Pencils

You will want to invest in a set of graphite (or shading) pencils for blending and shading. Although you can use a standard no. 2 pencil, a shading pencil is more gray than silver and can blend out much farther.

Shading pencils are often sold in sets and have hardness ranging from HB to 6B. A 2B is ideal for most shading within a freeform tangle, and a 4B is useful because it blends out farther than the 2B. An HB is often too light to complement a

technical pen's marks, and the 6B is often too dark for shading in small areas created by the patterns. When you purchase a set of shading pencils, familiarize yourself with each grade of pencil by making marks and blending on scrap paper.

Erasers

Erasers are an essential tool especially for creating gridline patterns. The type of eraser you choose is really a matter

of preference. I use two types of eraser most often. The first is a Pentel Hi-Polymer eraser that looks like a white rectangle. This eraser is durable, non-abrasive and erases large areas cleanly, which is ideal for erasing temporary gridlines. (Using a lighter stroke with a hard lead such as a 4B will also help for easy erasing.)

The second eraser I like is a battery-operated mechanical eraser with a small width that allows your to erase very small areas. For example, when drawing a sphere, the bottom portion of the circle is heavily shaded but the top usually has a highlight, which I create using a mechanical eraser.

Rulers

A simple ruler is needed to create straight lines within your drawing. A ruler will also help you keep your lines evenly spaced, which is important when creating a gridline pattern. A ruler that is clear or translucent will allow you to see through to the pattern, which is especially helpful when drawing on a diagonal.

Rulers can be found in a variety of lengths and most are beneficial in freeform tangling. A 6-inch (15cm) ruler allows you to easily work in a small space. You can also hold it steady with one hand, which is important for nice straight lines.

A 12-inch (30cm) ruler allows you to create long straight lines in larger areas, which is useful when creating gridlines that span the width and length of your paper.

An 18-inch (46cm) ruler allows you to create a diagonal line spanning corner to corner of an 8½" × 11" (22cm × 28cm) page. A 12-inch (30cm) ruler is just shy of making this diagonal

reach, so it might be worth it to invest in an 18-inch (46cm) ruler rather than piecing together multiple lines with smaller rulers.

Compass

Use a compass to create circles and curves. I recommend using a compass that can fit a technical pen or a Sharpie as well as a pencil. This will allow you to skip the step of tracing over the circles as you would need to if you created a circle with a compass that fits only a pencil. Staedtler offers an adjustable brand that can be found online or in office and art supply stores.

Blending Tools

There are a couple of options you can use to blend your pencil marks.

A tortillion is loosely wound paper tapered at one end. When using a tortillion to blend, it's important to be gentle because the tip can collapse inside the tube. Though this can be remedied by inserting a paper clip into the open end, the tip will never

be as rigid as when new. Tortillions are generally used for fine detail shading and small areas of shading.

Another tool is the blending stump. It is made of very tightly wound paper and has a usable point on either end. Blending stumps are much harder than tortillions and are used to smoothly blend larger areas.

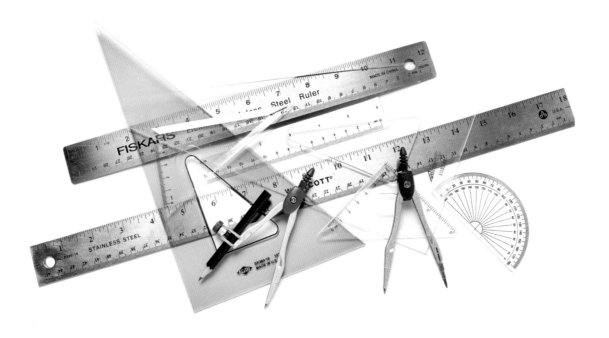

Technical Pens and Markers

Technical pens and markers are my preferred tools for drawing and coloring bold freeform tangles. The tools listed here are a great jumping-off point, but feel free to experiment with other tools and mediums as you gain confidence in your skills!

Technical Pens

Technical pens are essential for creating freeform tangles. They tend to be sold as a set with nib (tip) sizes ranging from 005 to 1. The range of nib sizes is important because the smaller sizes allow you to add very fine details and the larger sizes allow patterns to build the focal point and depth.

There are a variety of technical pen brands out there. The most easily accessible is Pigma Micron pens by Sakura. These come in a variety of nib sizes, are sold in sets and individually, and the ink is both waterproof and fade-proof. Waterproof ink is important so it doesn't smudge or smear when adding color over the top. As long as the pen marks are dry, watercolor or marker should glide right over the ink.

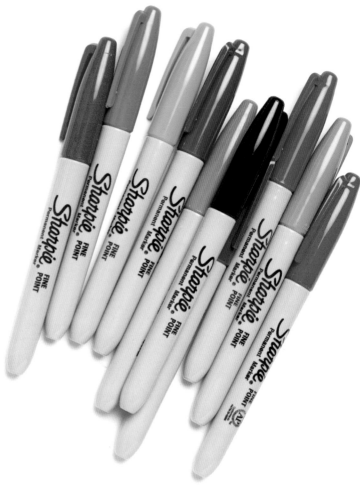

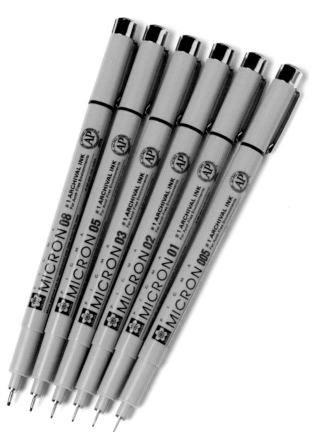

Though you can create different line thicknesses using any drawing instrument by going over your lines more than once, this creates the opportunity for mistakes. This is why technical pens are recommended.

Permanent Markers

Many brands of permanent markers are available. Permanent markers such as Sharpie or BIC Mark-It markers are the most commonly used for freeform tangles. They are inexpensive, easy to work with and create a dramatic end result to any drawing. With the number of colors and shades available, it's easy to create bold or soft looks or anything in between.

Like pens, permanent markers are available in a variety of different sized nibs like ultrafine, fine, chisel and brush. I recommend fine tip markers for freeform tangles. Ultrafine permanent markers tend to feather much more than fine markers, even though the tip is smaller, making them difficult to work with. To create thinner lines with a fine-tipped marker, simply use a lighter stroke by barely touching the tip to the page.

Blending with Markers

Permanent markers are alcohol-based, which allows the color to blend with other alcohol-based markers. I have experimented with several types of permanent markers and have found that Sharpies are the easiest marker to blend although it is possible to blend any brand with a bit of extra effort. With Sharpies, the ink remains wet for a little longer and that is important for the blending technique described in this book.

There are other markers that are made specifically for blending such as Copic, Spectrum Noir and Prismacolor. I tend to gravitate to using Sharpie, even with these other available options, because of how bold the color is and how affordable the markers are. The more expensive brands are worth the investment, but I will always have Sharpie markers in my art supply collection. Once you have learned to blend with Sharpie, you will find blending with the higher-quality, alcohol-based inks easy as well. They all require the same technique.

Choosing a Paper for Markers

When coloring your freeform tangles with permanent markers, it's important to choose the right paper. Before you lay down any color, practice on scrap sheets of the same type of paper as your drawing to test how the color might bleed or feather. No paper completely eliminates feathering, so practicing will show you how close to the original drawing line you can get without the color feathering into areas where you don't want it.

The only paper I have found that doesn't allow permanent marker to bleed through to the other side is RendR paper, which can be found in some craft stores and online. However, even this brand will produce a moderate amount of feathering. RendR sketchbooks are great if you want to use both sides of the paper and create a book of bold designs.

Visit createmixedmedia.com/zen-doodle-unleashed to download free bonus materials.

13

OTHER COLORING MEDIUMS

As you become more familiar with this basic list of tools, you may want to consider branching out and trying other mediums such as watercolor, colored pencil or oil pastels. Though they are not discussed in this book, you can also experiment using India ink, acrylic paint or even fountain pens in your freeform tangles.

Colored Pencil

Colored pencils are one of the easiest ways to add color to your drawings. They are available in a variety of colors and shades, and some brands can even be erased. The most important thing to consider when choosing a brand of colored pencil is the quality. Choose a pencil with the most color payoff with the least amount of effort.

One way to test the quality of the pencil is to make a practice mark with a heavy hand. If it's high quality, it should almost look like a marker. I prefer Derwent colored pencils, but there are plenty of other good brands out there such as Prismacolor or Faber-Castell.

Watercolor

Though watercolor is a challenging medium to master, it can lend beautiful transparent effects to your freeform tangle art because of the way it's applied in layers. In chapter 8, I suggest a very basic method for getting started in watercolor; if you find it's something you really enjoy, I recommend seeking out one of the many great resources available for learning more about the medium.

Watercolor is commonly sold in tubes or cakes or pans. You can mix tube colors easily to create different shades, and they have nice, bold color payoffs. However, purchasing a beginner set of watercolor cakes is also a good way to go because the set comes with a built-in limited palette and is typically less expensive than buying all of the tubes separately. The brand of watercolor is less important than with colored pencil because you can simply add more layers of watercolor to achieve the result you are looking for.

Watercolor pastels and watercolor pencils are other water-soluble tools

available, but the finished result is not of the same quality as working with true watercolors. Most leave behind marks that are difficult to blend to create the luminous watercolor look. Although the application may be easier than working with paintbrushes, it takes a lot more practice to achieve the watercolor look with water

Oil Pastels

Oil pastels (also called wax crayons) have a soft texture and are easily blended. After permanent markers, oil pastels are my favorite way to add color to a freeform tangle.

Just like the other mediums, there are several brands of oil pastels on the market. There's no need to invest in an expensive set of pastels when first learning to work with them because they all have about the same result. If you discover that using oil pastels is your preferred method of adding color to your drawings, I do recommend investing in higher-quality

pastels. Mungyo brand pastels are smooth and creamy in texture, which allows for easy blending. You will also need a set of blending stumps to easily blend in different-sized areas.

There are oil pastel papers on the market, but it is not necessary to invest in this type of surface. I have worked with oil pastels on several types of paper and have discovered that the result and ease of blending is not significant enough to justify the switch.

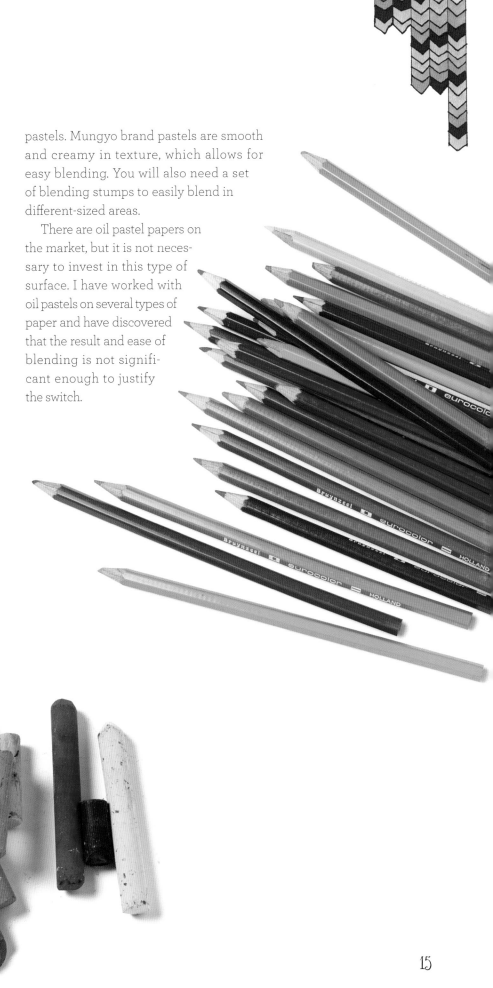

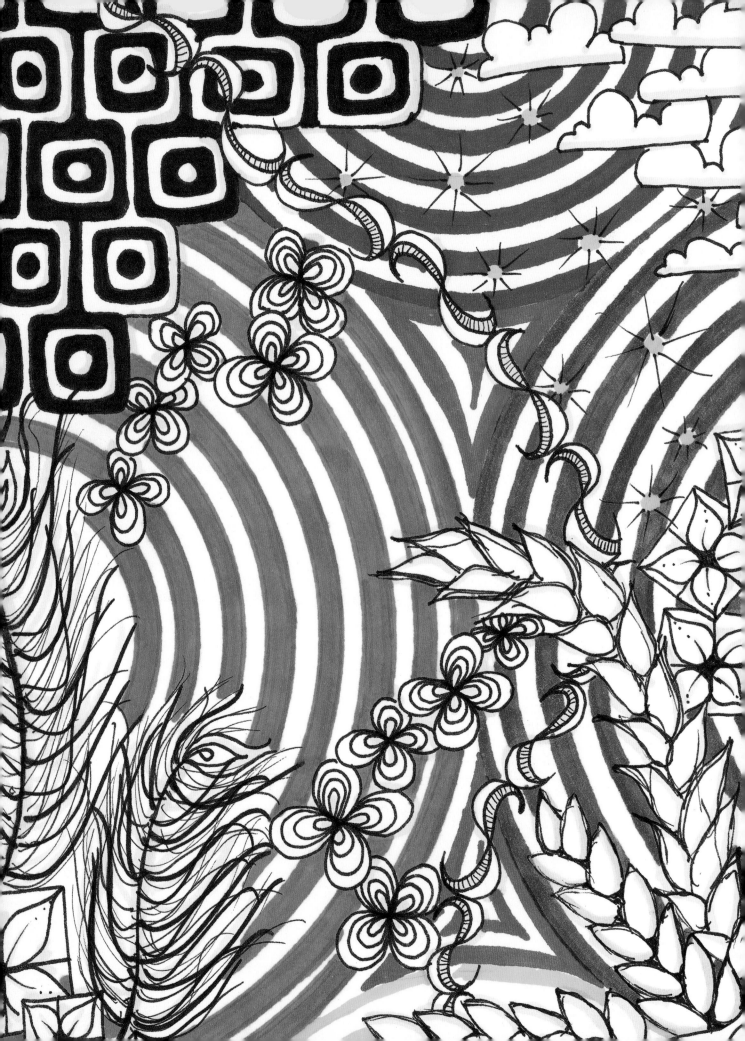

2

STROKES & PATTERNS

Certain elements make up a freeform tangle. The first, and most important, are the patterns that are used to create the drawing. An individual pattern is often repetitive and can be continued for an infinite amount of space (e.g., Crossword, Squircle and Xo). These patterns allow the drawing to appear as though it could go on forever.

Some patterns have a clear beginning and end, but can be overlapped to appear repetitive (e.g., Tri-Inside, Berried Leaves and 8 Flowers). These patterns are often varied in size when overlapped, and they are heavily shaded where they overlap to create a more dimensional look.

Other patterns form a long line when repeated rather than expanding widthwise or lengthwise like other patterns (e.g., Alli, Tangled and Leafing). These patterns are used when you want to create a unique line to separate your drawing.

Geometric patterns are classified by the ease of creating variations to the pattern. Basic patterns have fewer steps and a more open design whereas advanced patterns have more steps making it more difficult to add your own twist. Organic patterns are based on nature, and gridline patterns require a grid to create them. There's little to no variation possible within these patterns because once a variation is attempted, it usually creates a whole new pattern.

Filler elements are patterns used to fill empty space. Filler patterns add a bit more visual interest in what would otherwise be white space. They can also be used to create a variation to the main pattern of a drawing.

Four Types of Tangle Art

Four different types of tangle art are popular today: Zentangle, Zen doodle, freeform tangle and Zentangle-inspired. Though they all use repetitive patterns, they also have key differences. Once you know how to draw a handful of patterns, you should experiment with the different types of tangle art and see which ones you prefer. Knowing the different types of tangle art can help to expand your creative outlets.

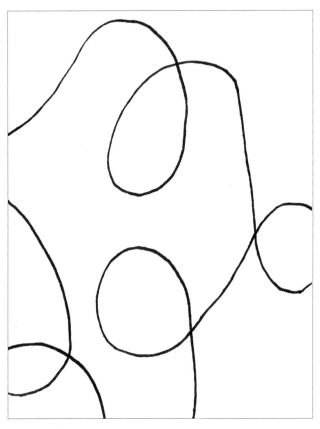
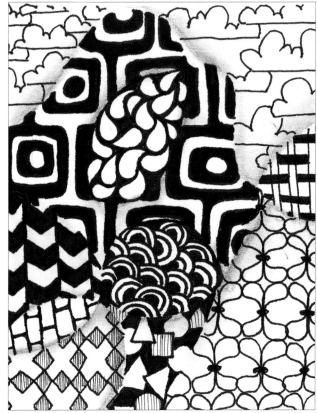

Zentangle
Zentangle® was created by Rick Roberts and Maria Thomas as a meditative way to utilize repetitive patterns. Zentangle starts with a "string" (see left image) generally drawn in pencil and used to separate the different patterns. This string can disappear into the drawing or can be used as a guideline for shading (see right image). Zentangle is completed with black ink and shading with no color.

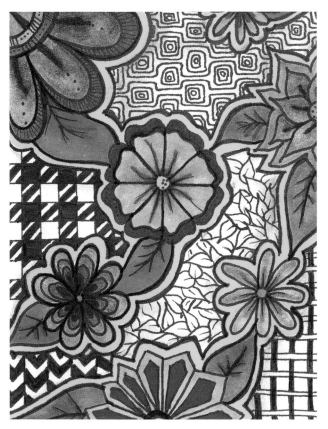

Zen Doodle

A Zen doodle uses small drawings or doodles that are surrounded by repetitive patterns that bring the doodles together. Here I drew flower doodles and filled the spaces between them with various filler patterns. A Zen doodle usually includes color and shading to differentiate between the doodles and the patterns.

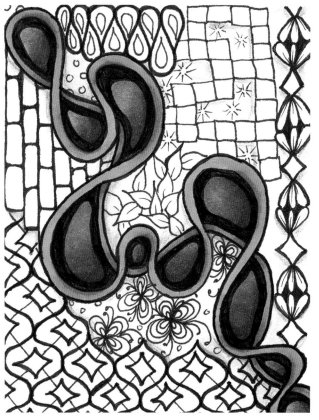

Freeform Tangle

Freeform tangles use patterns only to complete the drawing. They are less restrictive than the traditional Zentangle because there is no string to contain the patterns. The patterns are made to appear overlapping and flowing into one another. Color is used frequently in this type of tangle art but not required to be considered a freeform tangle.

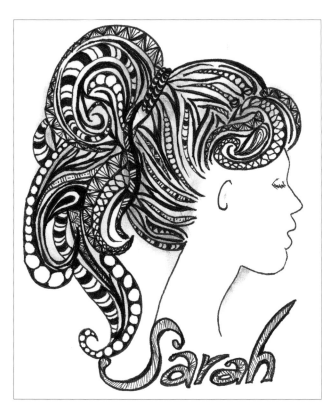

Zentangle-Inspired Art

Zentangle-inspired art starts with a picture drawing, such as a face, animal or flower, then repetitive patterns are used within the drawing to accentuate specific areas. The original drawing without the patterns can be as simple or complex as desired but is commonly a simpler line drawing. This allows the patterned portion of the drawing to stand out.

HOW TO USE THIS BOOK

I have organized the patterns in this book into five categories: basic, intermediate and advanced geometric, plus organic and gridline. Practice each of them before starting your first freeform tangle to determine which are your favorites. I recommend practicing patterns on a 3" × 3" (8cm × 8cm) piece of cardstock—also called a tile. This will give you enough room to experiment with the size, shading and coloring at least twice for each pattern. Understanding the five different types of patterns is important when first learning to create repetitive patterns. It is much easier to create a pattern like Geo Flower or Feathered after you've learned the more basic patterns.

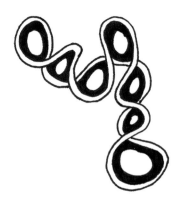

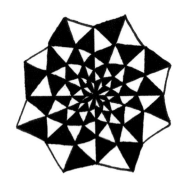

Basic Geometric Patterns

Basic patterns require fewer steps. They generally have an open design and are great for adding color. Most of the basic patterns can be used as focal or supportive elements. See page 24 for a full-page tangle example using only basic patterns and filler elements.

Intermediate Geometric Patterns

Intermediate patterns usually take a few more steps than basic patterns or the steps are slightly more technical. Most work best as a focal pattern, but keep in mind that any basic, intermediate or advanced pattern can be used as either a focal or supportive pattern.

Advanced Geometric Patterns

Advanced patterns require even more steps to complete the final look. There are also fewer opportunities for creating variations within the patterns. When coloring these patterns, the technical aspect can be lost if you use colors that are too dark.

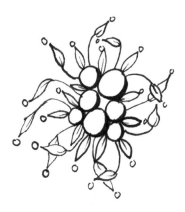

Organic Patterns

Organic patterns are reminiscent of things that can be found in the world such as flowers, leaves and tree branches. Most of these patterns look great with a sketchier stroke to make them look more natural. When practicing the sketchy stroke, try it first with organic patterns.

Gridline Patterns

Gridline patterns require a gridline as the first step. This gridline acts as a clear guide for placing the pattern. Gridlines can be permanent and part of the pattern or created in pencil and erased after the pattern lines are added. You can also use graph paper as a grid.

Focal vs. Supportive vs. Filler Elements

Determining where to place the patterns on the page is a matter of personal preference and inspiration. There are three elements to a freeform tangle: focal, supportive and filler. Almost every pattern can be used as a focal or supportive element with the exception of organic patterns, which are always focal. When first learning to complete a freeform tangle, it's best to work the elements in order from focal to supportive to filler. Doing so will help to keep the drawing from becoming overwhelmed by a specific type of pattern.

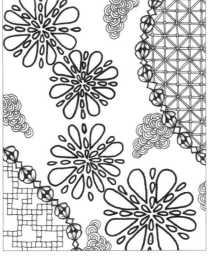

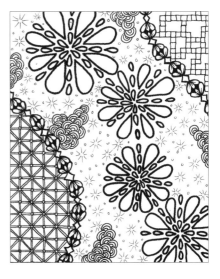

Focal

The focal patterns in a freeform tangle are the pattern, that the eye is immediately drawn to. They are the equivalent of the focal point or center of interest of a painting or photograph. In a freeform tangle, you want to start with the part of your drawing that will stand out. One way to do this is by selecting a larger nib like an 08 or an 05 multiliner pen. The focal pattern can also be a unique organic pattern or colored or shaded in a bold way.

Supportive

Supportive patterns surround the focal patterns. These patterns are the bulk of any freeform tangle. Vary your pen sizes when adding the supportive patterns to create contrast between those you add as well as the focal pattern.

Filler

Filler patterns should not be confused with beginner patterns. Filler patterns are the easiest to draw yet often the most important patterns in a freeform tangle. They are completed in one or two steps and require no shading or color for the completed look. They are very important because they fill in the holes of your art and make all of the patterns on your page flow into each other. It's good to have an array of filler patterns to choose from. See page 117 for a reference booklet for 101 filler patterns to use as reference in your tangle art!

Visit createmixedmedia.com/zen-doodle-unleashed to download free bonus materials.

21

FOUR TYPES OF STROKES

Four types of pen strokes are regularly used in freeform tangles: solid, sketch, flick and flourish. These strokes can be combined to create visual interest and perspective within a drawing. They can be used alone or in combination with each other. It's important to practice the different strokes not only so you can re-create them in your own tangles, but so you can recognize them within a pattern you may want to duplicate. While no strokes are particularly difficult, it helps to practice them as much as possible to develop your muscle memory and get an idea as to how creating each stroke feels. Practicing and memorizing your strokes will make your lines more smooth and deliberate on the page and your patterns more natural overall.

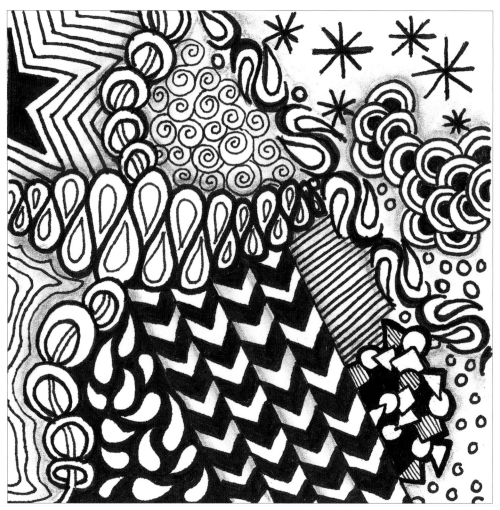

Solid Stroke

A solid stroke is the most common stroke used in freeform tangling. The solid stroke may vary in thickness (particularly thicker in curves), but the edges and ends are crisp. When creating a solid stroke, you want to hold your pen securely and drag the line in one long stroke. If you don't make a line long enough and you try to extend it after lifting your pen, your line will not look as smooth as it would in one single stroke. If your line looks choppy because you lifted your pen, try going over it again with a larger nib pen, extending the line to the length you need.

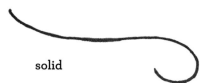

solid

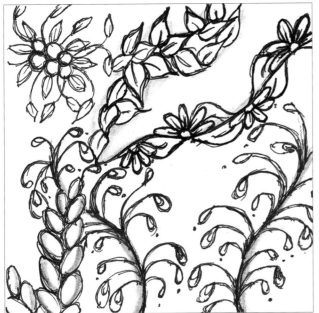

Sketch Stroke

The sketch stroke is a relaxed line best used for organic patterns and patterns without a lot of intricate details. The lines are literally sketched onto the page in short, quick strokes to convey a loose idea of the pattern. When using the sketch stroke, keep each stroke close together so the direction of the pattern is clear. This type of stroke is great for someone with an unsteady hand because the lines do not need to be crisp and concise as with the solid stroke.

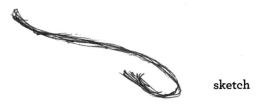

sketch

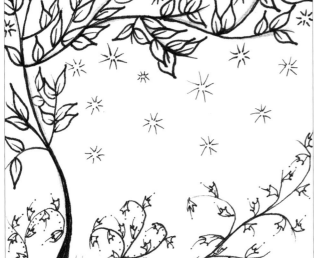

Flick Stroke

The flick stroke is used to add depth or shading to a pattern. It is commonly found in the middle of a flower petal. It is slightly thicker at one end and is created by a single, quick pen motion. To re-create a flick stroke, place the pen where the thickest portion of the stroke should be and quickly brush the pen across the page. This may take a bit of practice to figure out how hard to press and how to move the wrist to get the length desired for the line, but with time it becomes second nature.

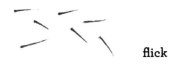

flick

Flourish Stroke

The flourish stroke is similar to the flick in that it is slightly thicker on one end, but it is much longer than a flick stroke. This type of stroke is commonly used in organic patterns for flower stems or vines. To create this stroke, place the pen where the thickest area of the stroke should be, draw a line to where it should almost end and finish the stroke with a quick flick to create a tapered look.

flourish

Visit createmixedmedia.com/zen-doodle-unleashed to download free bonus materials.

23

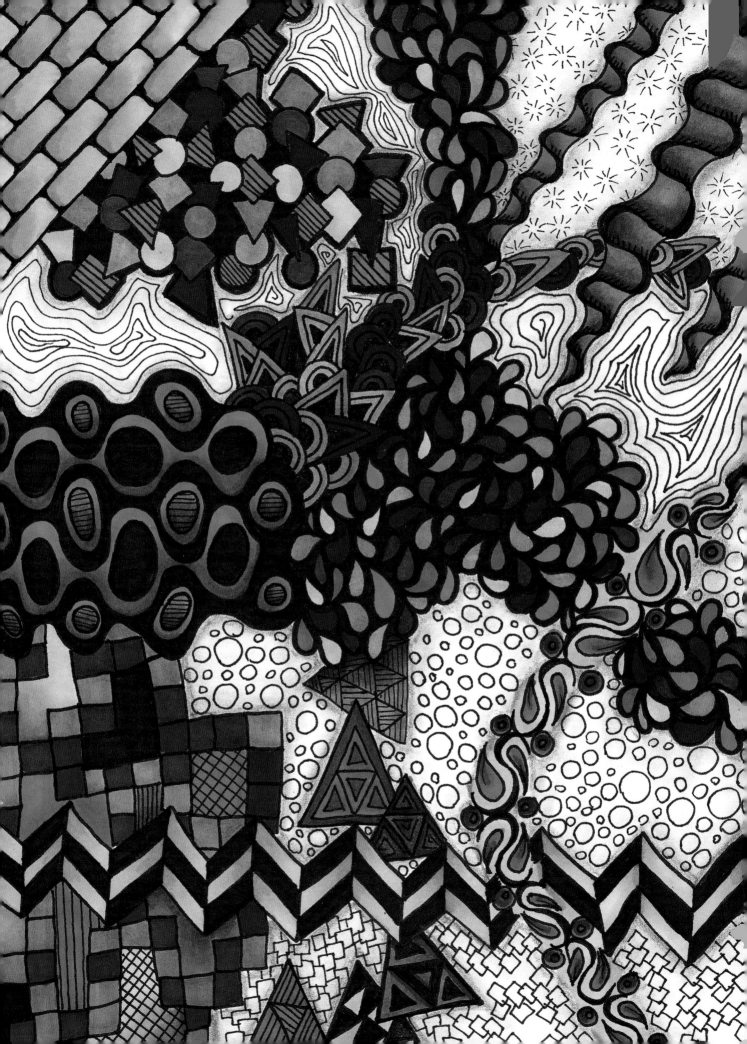

3
BASIC PATTERNS

Basic patterns are the foundation of all patterns. They tend to have fewer steps and look less technical in comparison to intermediate and advanced patterns, which makes them appear to be easier when in fact they're just less time-consuming. Basic patterns have a simple look to them, which allows for more variations that can lead to new patterns. Drawing a freeform tangle can look just as complex using all basic patterns as using all advanced patterns. Working more basic patterns into a freeform tangle creates a great opportunity to put a unique spin on simple linework.

The freeform tangle on this spread was created using only basic patterns and filler patterns with very few variations. The overlap of patterns and the way they are shaded and colored is what makes this drawing appear more complex when in fact only simple patterns are used.

Basic patterns are best for attempting variations. The easiest way to do this is to combine filler elements to create the pattern. Another way is to work with double lines instead of a single line when creating patterns.

Basic Pattern
TRI-INSIDE

The Tri-Inside pattern may be too basic for a focal pattern but makes an excellent supportive pattern. Practice with shading to give the triangles a floating appearance.

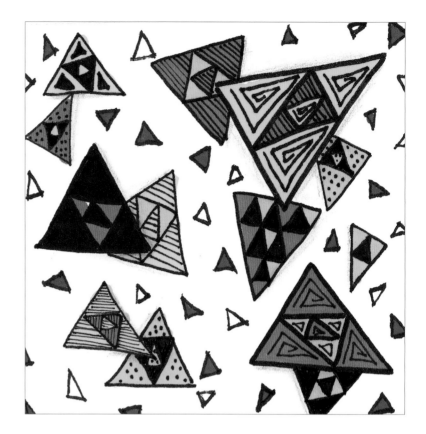

1 Draw a triangle.

2 Draw a triangle inside the first triangle, facing in the opposite direction.

3 Draw a third triangle inside the second triangle, facing in the opposite direction. Now there should be a total of seven triangles.

4 Choose a filler element for the three outer triangles and inner triangle, and color in the middle three triangles. This is your first Tri-Inside.

5 Create additional Tri-Inside patterns facing different directions. Choose different filler patterns for each new Tri-Inside and use different pens to add depth.

6 Completed Tri-Inside pattern.

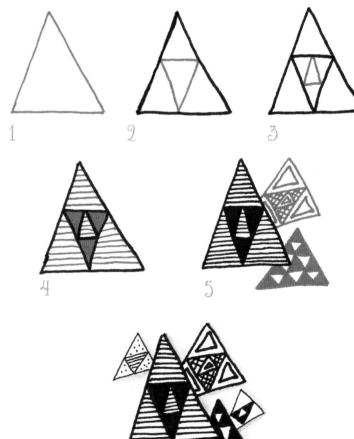

Sign up for our free newsletter at CreateMixedMedia.com.

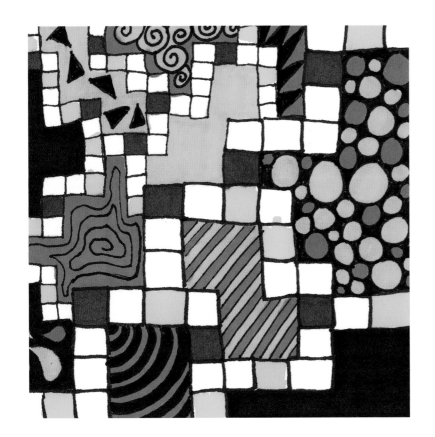

Basic Pattern

CROSSWORD

Crossword is one of my favorite patterns because it can be used as a focal, supportive or even a filler element depending on the size of the squares and how much area you allow the pattern to cover. Practice creating larger open areas between the lines of squares to place other patterns within the Crossword pattern.

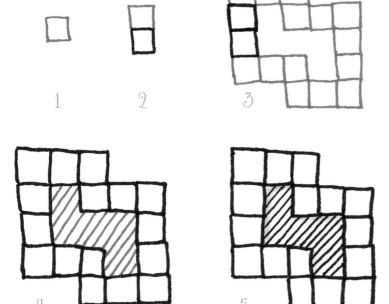

1 Draw a square.

2 Draw three lines off the square to create another square.

3 Repeat step 2, occasionally changing the direction of the chain of squares and allowing the pattern to create a gap between the squares.

4 Inside the gaps add a filler element, or color in the gap.

5 Completed Crossword pattern.

Basic Pattern
SPLASH

Splash is a very bold pattern and makes a fantastic focal element. Remember to keep the teardrop shapes touching because putting too much space between the drops will create a lot of black space in the final pattern.

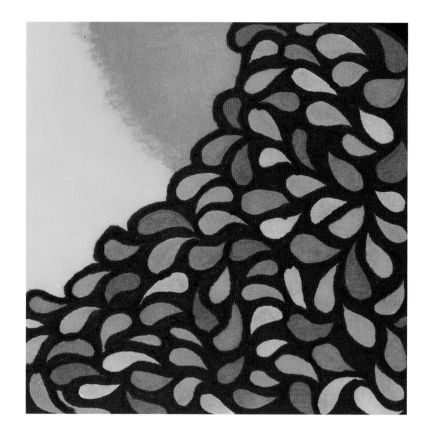

1 Draw a teardrop shape. Use a permanent marker or an 08 multiliner pen for the most dramatic results.

2 Draw another teardrop shape next to the first so they are touching.

3 Continue drawing teardrop shapes at different angles, all touching, until the space for this pattern is filled.

4 Color in the empty spaces between the teardrops with black marker.

5 Completed Splash pattern.

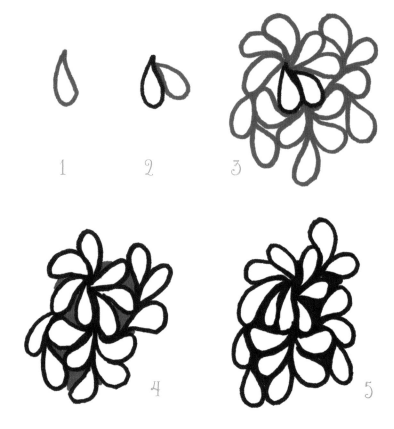

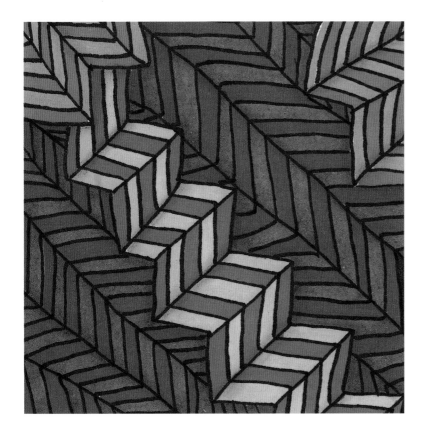

Zig Zag

The Zig Zag pattern can be used in a large area and still have a lot of dimension when repeated in many different directions as shown in the finished color tile. Remember to shade at every other vertical line to create a 3-D effect.

1 Draw a zigzag line at the top of the space for this pattern.

2 Continue drawing zigzag lines like the first under each other until the space is filled.

3 Draw a vertical line at every peak and valley to connect the zigzag lines. Color every other section.

4 Completed Zig Zag pattern.

1

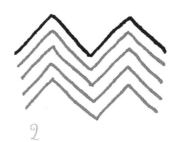

2

3

4

Visit createmixedmedia.com/zen-doodle-unleashed to download free bonus materials.

29

Basic Pattern
Esses

Esses has a number of possible variations and is a great pattern to work with when first learning to put your own twist on existing patterns. Elongate the S shape and try different ways to fill in the curves.

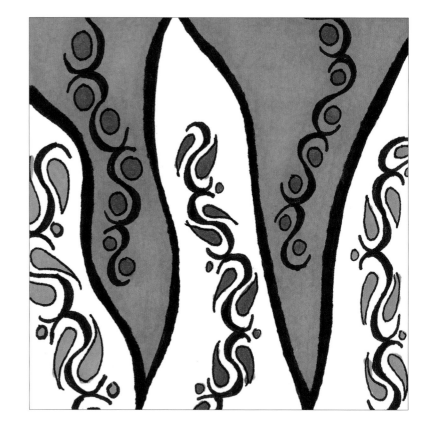

1 Draw the letter S.

2 Under the first S, draw a backward S that touches the first S.

3 Continue the chain of backward and forward S shapes until the space for the pattern is filled.

4 Thicken the curves of every S.

5 Embellish the chain of S shapes with circles and teardrop shapes.

6 Completed Esses pattern. Experiment by varying the size of the S shapes or drawing the S shapes on a horizontal line instead of vertically.

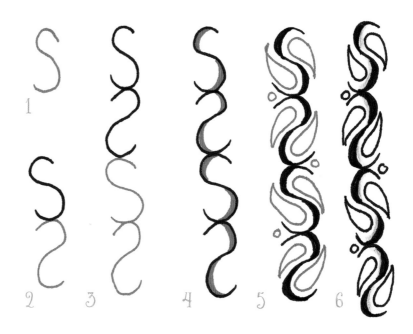

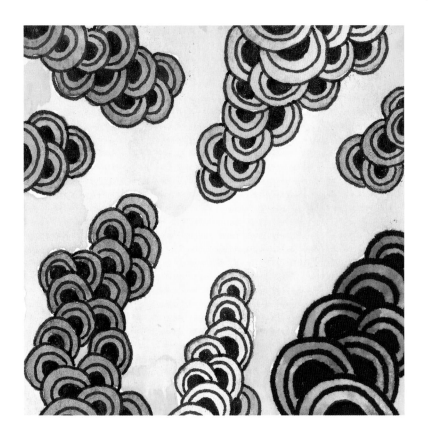

Peek-a-Boo

The Peek-a-Boo pattern is easy to build upon and can cover a vast area of the page. Create dimension by shading where the curves touch each other or vary the size of the arches.

1 Draw a set of three arches that go over each other.

2 Color in the bottom arch as a half circle. Draw three more arches off the side of the first set. They can be the same size as the first set or slightly smaller or larger.

3 Continue adding arches until you fill the area for the pattern.

4 Completed Peek-a-Boo pattern. For a variation, use triangle shapes instead of arches. Or use both arches and triangle shapes to fill the area. (See the reference booklet for examples.)

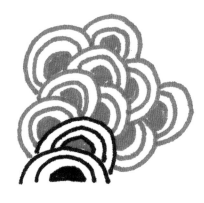

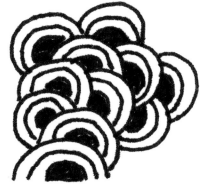

Visit createmixedmedia.com/zen-doodle-unleashed to download free bonus materials.

31

Basic Pattern
DoTTie

Shade around the curves of the oval shapes to add some dramatic dimension to this pattern. Try using different types of filler patterns to vary the look of Dottie.

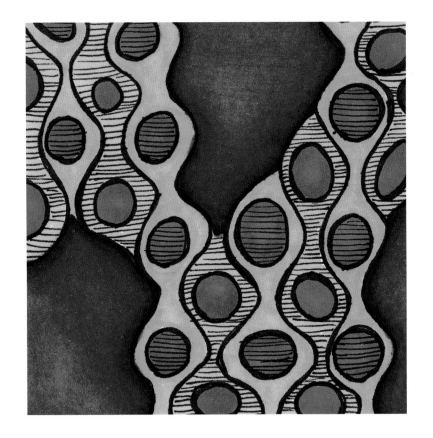

1 Draw a wavy horizontal line. If it works better for you, draw the pattern vertically.

2 Draw another wavy horizontal line below, but not touching, the first.

3 Continue drawing wavy lines until the space is filled.

4 In the middle of the larger gaps, draw a circle that almost fills the gap. These circles should mimic the gap so they may look more like ovals or eggs or some other rounded shapes. That's what makes this pattern unique.

5 Color in the circles or outside the circles alternating at each strip.

6 Completed Dottie pattern.

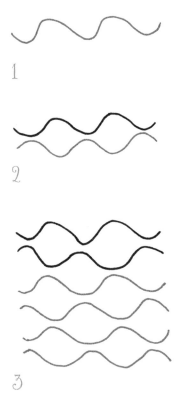

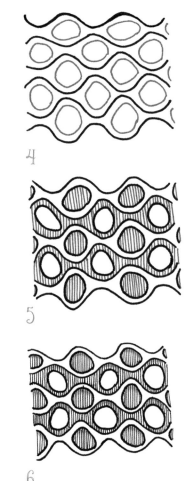

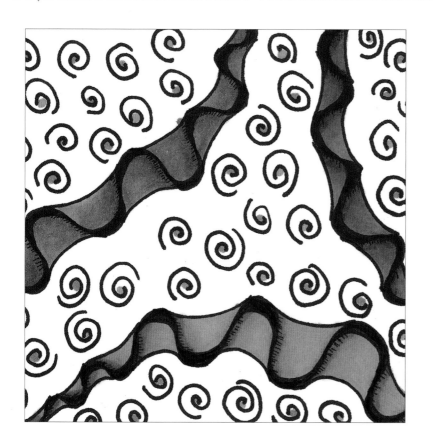

The tiny flick strokes in this Alli pattern really help to create dimension. When shading, the darkest portion of the shade should be where the flick strokes are placed.

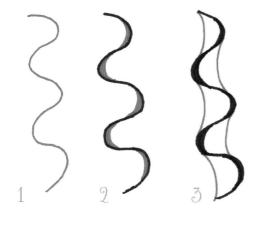

1 Draw a wavy vertical line.

2 Increase the thickness of the curves on the wavy line.

3 Add a curved line to the open areas to connect the curves of the original wavy line.

4 Add tiny flick strokes to the wavy line using an 01 or 005 multiliner pen.

5 Completed Alli pattern. Try a fun variation by increasing and decreasing the size of the curves of the wavy line.

Visit createmixedmedia.com/zen-doodle-unleashed to download free bonus materials.

33

Basic Pattern
OVERLAPPED

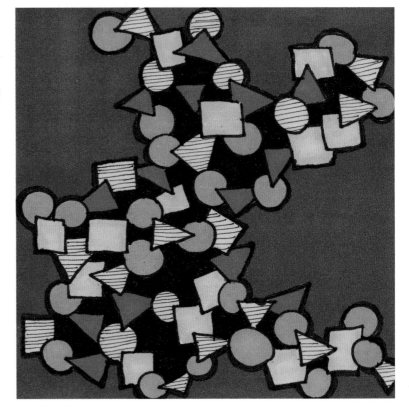

Overlapped is another pattern that can be used as a supportive or focal pattern depending on where it's placed and how much it covers the page. Remember to make the shapes about the same size to maintain a consistent look throughout the pattern.

1 Draw a square, circle and triangle in the center of the space for the pattern.

2 Continue drawing squares, circles and triangles of the same size slightly behind each other to look like they are overlapping.

3 Color in any spaces between the shapes.

4 Use a filler pattern to color in some of the shapes.

5 Completed Overlapped pattern.

1

2

3

4

5

Sign up for our free newsletter at CreateMixedMedia.com.

Bricks can be a time-consuming pattern. Start by placing this pattern in small areas until you have a feel for how long it takes to complete.

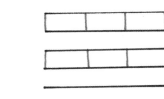

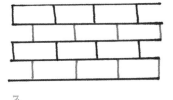

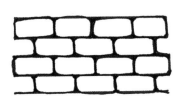

1 Using a ruler, draw a set of horizontal lines to fill the space for the pattern.

2 Connect the first two lines with a vertical line. Continue making vertical lines, breaking the row into rectangles. Every other row of bricks should line up with each other.

3 In the first empty row, draw vertical lines that measure up to the middle of the bricks of the previous row. Fill in the rest of the empty rows in the same way.

4 Draw a tiny curve in all the corners of every brick to cut off the corners.

5 Trace around every brick to balance out the lines. Do this step freehand for a natural weathered look to the bricks.

6 Completed Bricks pattern. Also try varying the space between the horizontal lines.

Visit createmixedmedia.com/zen-doodle-unleashed to download free bonus materials.

35

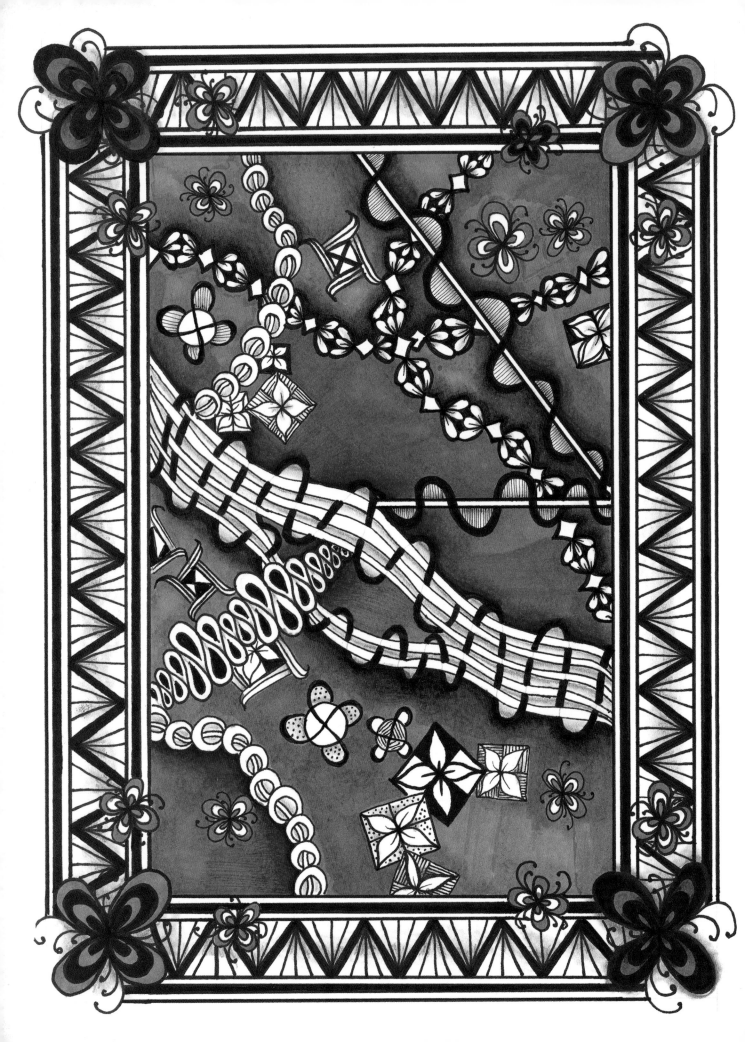

4

INTERMEDIATE PATTERNS

Intermediate patterns are a bit more detailed than basic patterns. They are still basic enough to create a variation fairly simply, but the initial process of creating the pattern may take a little longer than with a basic pattern. Intermediate patterns are great to use anytime, but I especially recommend them for people just starting out with freeform tangle drawing because they look technical and intricate without the pressure of having to follow more steps for the end result. Intermediate patterns are perfect for practicing with shading. Most of them depend on shading within the pattern to create a more dimensional look. The facing page is a complete drawing done with only intermediate patterns. I left out the element of filler patterns to help show the shading within and around the patterns.

Intermediate Pattern
RAINDROPS

When adding Raindrops to a drawing, consider lightly drawing a line with pencil first to show the direction you want the pattern to go. This is especially helpful when the pattern doesn't follow a straight line.

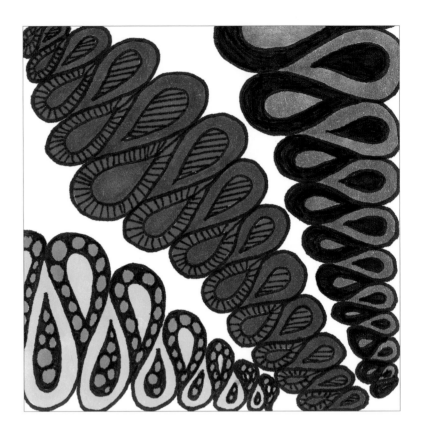

1 Draw a raindrop shape.

2 Sharing a side of the first raindrop, create a second raindrop shape in the opposite direction.

3 Continue adding raindrop shapes until the desired length is reached.

4 Draw a smaller raindrop inside each existing raindrop.

5 Use filler patterns to fill in the sections of the pattern.

6 Completed Raindrop pattern.

7 For a variation, when drawing the chain of raindrops, vary the size of the shapes.

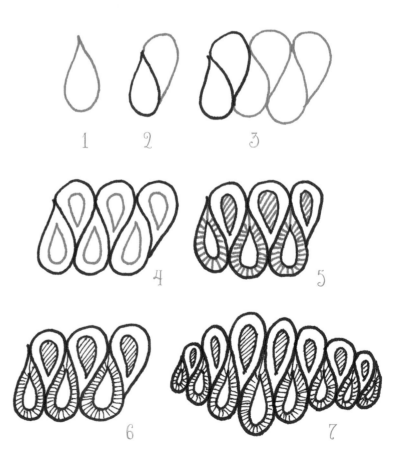

Sign up for our free newsletter at CreateMixedMedia.com.

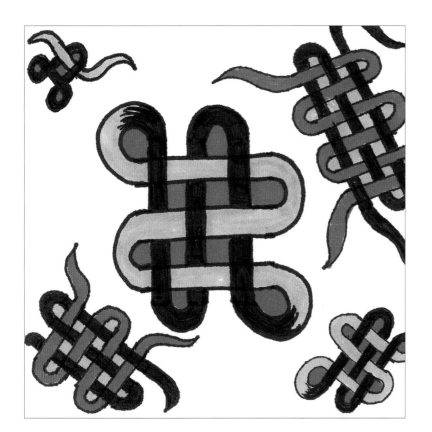

Woven

Woven makes a great supportive pattern when placed between two focal patterns. This helps bring the patterns together in a unique way. You don't always need to show the tapered ends of the strings; they can also disappear beneath another pattern as shown in the drawing on page 36.

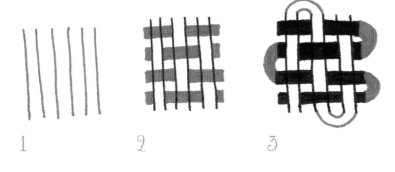

1 2 3

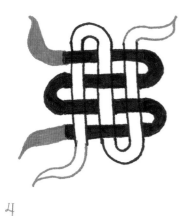

4 5

1 Draw several vertical lines close together, evenly spaced. The first two lines are considered a rope followed by a space then another rope, etc.

2 Draw a thick horizontal line that crosses over every other rope and space created in the first step. This will appear to go over and under the ropes. Continue drawing horizontal lines like this until the pattern is full.

3 Connect every other horizontal line with a small arch. Do this on both sides, then do the same for the vertical lines. This should make it appear as though two long ropes create the pattern.

4 Taper the ends of the ropes.

5 Completed Woven pattern.

Intermediate Pattern
FLOWER WINDOWS

The Flower Windows pattern has two variations in this book; the other option is a gridline pattern on page 74, which has a flatter appearance when completed. This intermediate pattern uses shading and filler patterns to achieve the overlapping look.

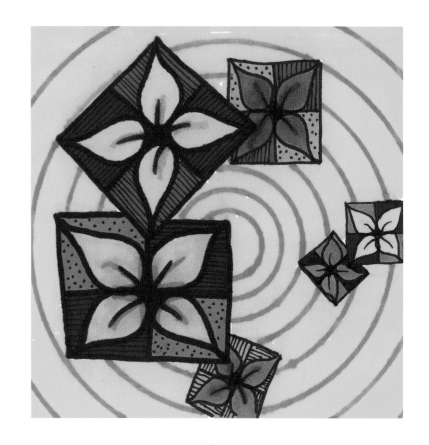

1 Draw a square, then divide it into four smaller squares.

2 In each small square, draw a petal shape so the wide end of the petal is at the intersection.

3 Place a flick stroke followed by a dot at the center of each petal to add dimension.

4 Use a filler pattern to fill the space around the petals. This is your first Flower Window.

5 To complete the pattern, draw more overlapping Flower Windows. Use a different filler pattern around the petals for each Flower Window.

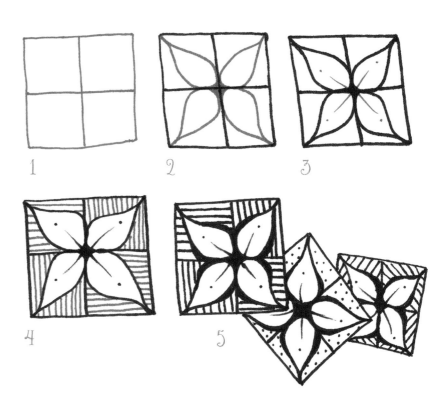

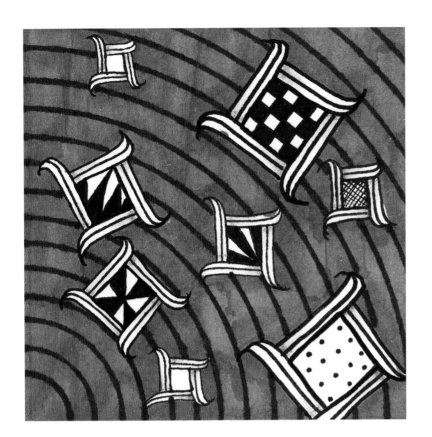

Intermediate Pattern
SWOOSHY SQUARES

In Swooshy Squares, use different filler patterns for the center squares. Remember to shade where the lines around the square meet to add a bit more dimension to the pattern.

1 Draw a square.

2 Draw a line off of each side of the square, with the ends curving away.

3 Add two supporting lines to each side of the square, tapering them into each other.

4 Color in or add a filler pattern to the square. This is the first Swooshy Square.

5 Add more Swooshy Squares around the first using different sized pens. Do not overlap the squares, but place them close together and touching one another. Use a different filler pattern for each Swooshy Square.

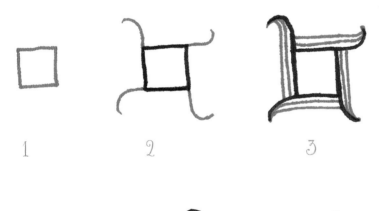

1 2 3

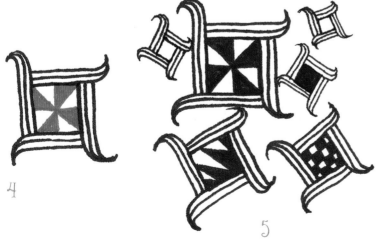

4 5

Intermediate Pattern

Daisy Diamonds

Daisy Diamonds is one of my favorite patterns. I often use it as a focal pattern. To help the pattern stand out, allow the Daisy Diamonds to weave through the entire drawing with a nice bold outline and effective shading.

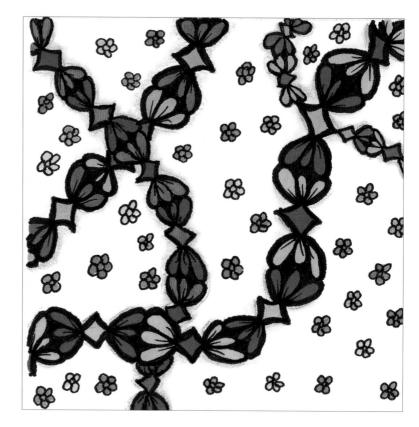

1 Draw a loop similar to a lowercase cursive L.

2 Draw a second loop that mirrors the loop from step 1.

3 Repeat the previous two steps until you've filled the space for the pattern. You now have a chain of petals and diamonds.

4 Draw a petal shape on both sides of each of the existing petals in the chain.

5 Finish the pattern by coloring in the spaces around the petals. Use a flick stroke in the middle of every petal. Darken the outline to balance the pattern.

6 Completed Daisy Diamonds pattern.

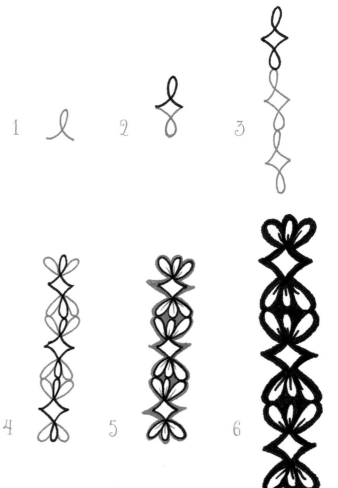

Sign up for our free newsletter at CreateMixedMedia.com.

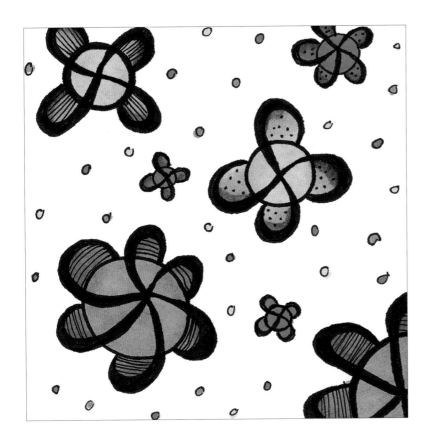

ORbS

The Orbs pattern is used mostly as a supportive pattern. Vary the amount of J shapes for a unique look when you have several Orbs near each other.

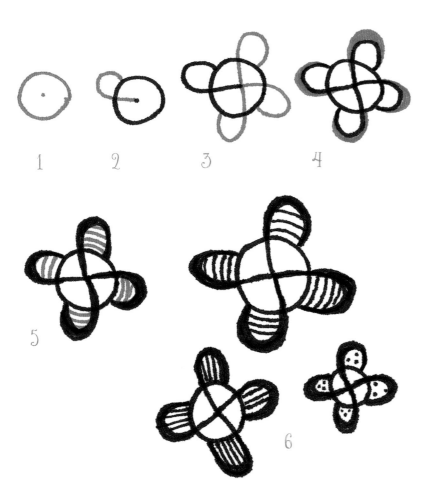

1 Draw a circle with a dot in the center.

2 Draw a J shape with the top of the J starting at the dot. The curve of the J should go outside the circle and curve around to touch the circle.

3 Continue drawing more J shapes evenly spaced around the circle.

4 Make the curve of the J shapes a little thicker.

5 Draw a few lines inside the loop between the curve of the J and the outline of the circle.

6 Completed Orbs pattern.

Intermediate Pattern
ROUND-A-POLE

This is a great focal pattern that can be used to create a boundary between supportive patterns. When using several Round-a-Pole patterns, vary the filler pattern used inside the curves so each pole has its own unique look.

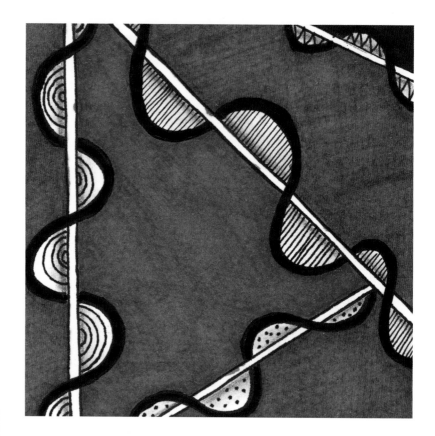

1 Draw two vertical lines next to each other. This is the pole.

2 Draw two lines that curve to the left of the pole and continue back to touch the pole. Extend the pole to meet these lines if needed.

3 Draw two lines that curve to the right of the pole and come back to cross over the pole toward the left side.

4 Continue drawing curved lines like this until you reach the end of the pole.

5 Color in the curved lines and use a filler pattern in the spaces between the curved lines and the pole.

6 Completed Round-a-Pole pattern.

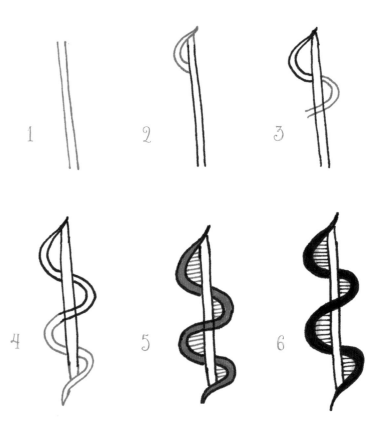

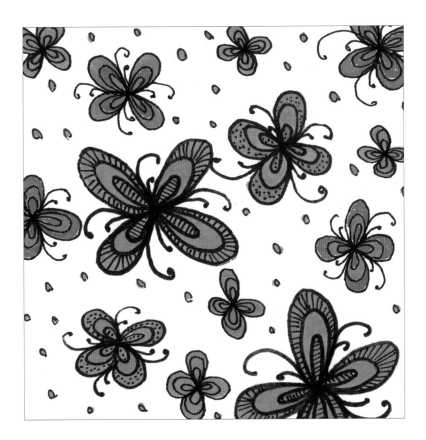

Intermediate Pattern
8 FLOWERS

8 Flowers is a fun pattern to create. Use different types of accents on the petals to give each flower a unique look. Also try to vary the size of the 8 Flowers pattern when placing several near each other.

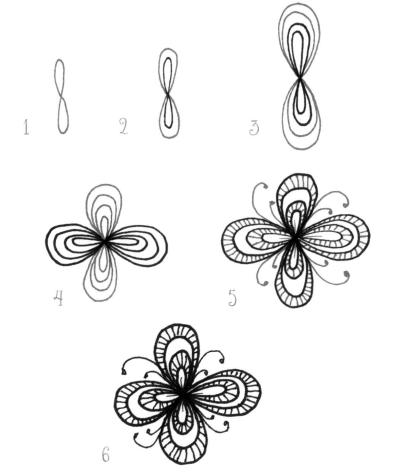

1 Using a continuous line, draw a slightly elongated number 8.

2 Starting at the middle point of the first 8, draw another 8 going around the first and meeting back at the middle.

3 Continue drawing 8s around each other. (Three to five 8s are a good number to stick to.)

4 Turn your page and create 8s like the previous steps, intersecting at the middle of the previous set of 8s.

5 Draw flourish lines between the petals and use filler patterns to embellish the pattern.

6 Completed 8 Flowers pattern.

Visit createmixedmedia.com/zen-doodle-unleashed to download free bonus materials.

45

Intermediate Pattern
Zig Zag Border

Zig Zag Border is a bold pattern that can be used to border a drawing as shown on this page. You can also taper the ends of the pattern to alter the perspective of the design. For best results, use a ruler for the straight lines that begin the pattern.

1 Draw three vertical lines with the middle line thicker than the others. Place them close together.

2 Draw three more vertical lines about ¾ of an inch (2cm) to the side of the first set. Continue this until the area for the pattern is filled.

3 Using an 08 multiliner pen, draw a zigzag line in the gap between the two sets of three lines.

4 Draw three lines that start at each point of the zigzag and extend to the first vertical line.

5 Completed Zig Zag border.

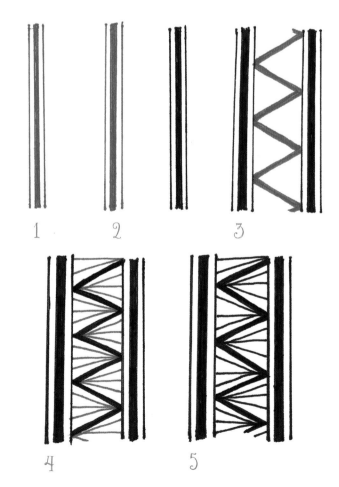

1 2 3

4 5

Sign up for our free newsletter at CreateMixedMedia.com.

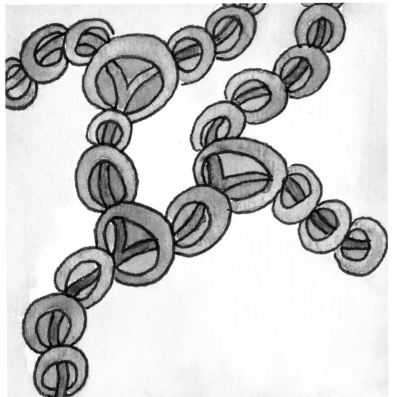

Noodle-O's

This pattern allows for several variations. Try adding details inside the Noodle-O's or on the string for a unique look. Let the Noodle-O's split at several sections on the page to allow the pattern to act as a boundary between different supportive patterns.

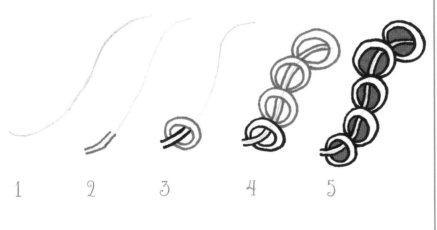

1 2 3 4 5

1 Using a pencil, draw a slightly wavy line. This is the direction your pattern should go; this line will be erased later.

2 Draw two short lines going along the pencil line.

3 Starting halfway up the short line, draw a circle that closes off the top of the short lines. Draw another circle around the first.

4 Draw two more short lines. The two circles going around these lines should touch the previous circle. Repeat.

5 Color the space between the inner circles and the lines. Erase the pencil line.

6 Completed Noodle-O's pattern.

7 Variation: Use filler patterns to color the space between the inner circle and the line.

8 Variation: Split the line into two lines.

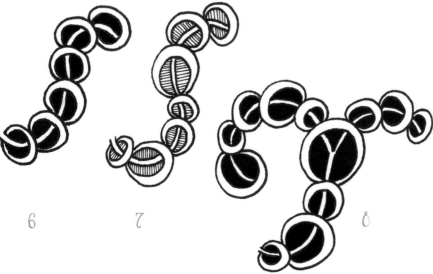

6 7 8

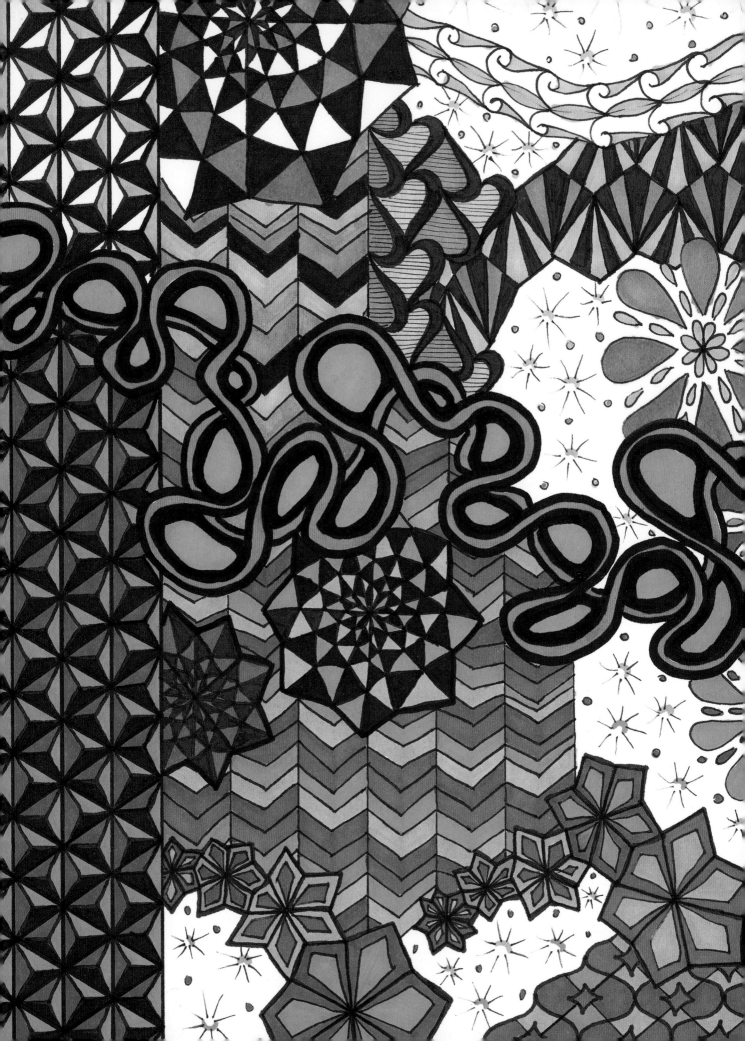

5

ADVANCED PATTERNS

Advanced patterns are advanced for a number of reasons. One, the pattern may require specific shading to create a 3-D effect. Two, the pattern may require the use of different sized multiliner pens for the finished look. And three, the pattern may have several steps to achieve the finished look.

More often than not, it is difficult to add variations to advanced patterns because they tend to have small details within the pattern. To create a variation, it may be necessary to change the direction of a line or even omit a line. Although variations can be difficult, sometimes by making a variation to an advanced pattern, a new pattern will be discovered.

The drawing on the facing page consists of advanced patterns and filler elements. I used different shades of teal, pink and gray to complete the drawing rather than complex shading to keep the focus on the technical linework.

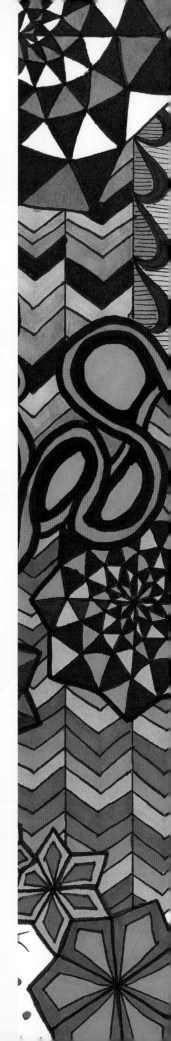

Advanced Pattern
TANGLED

When creating the Tangled pattern, be cautious of how large the waves are in the first step. It is easy to get carried away and have the pattern take up too much space on the page. Add some filler patterns in the ovals or the space around the ovals to add a little variation.

1 Draw a double squiggly line that has some dramatic curves.

2 Starting at one end of the squiggly lines, continue the lines so they overlap and the ends connect.

3 Where there are loops, draw circular shapes. They won't be perfect circles. Color the space between the lines and the circular shapes.

4 Completed Tangled pattern.

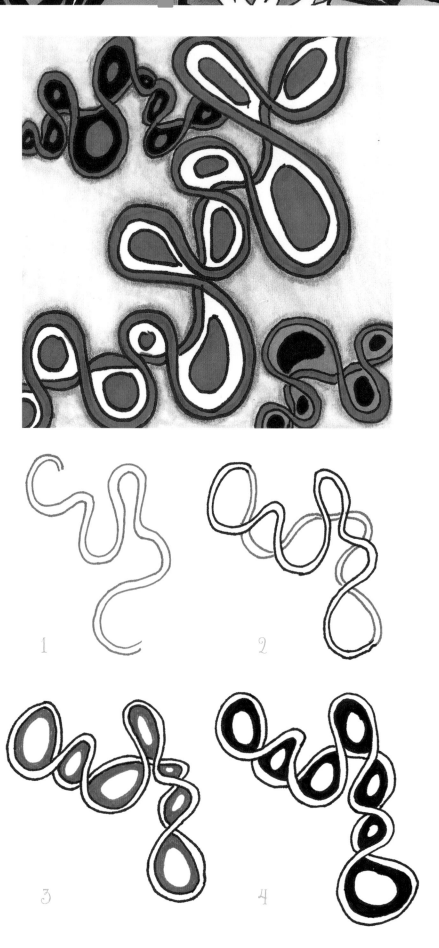

Sign up for our free newsletter at CreateMixedMedia.com.

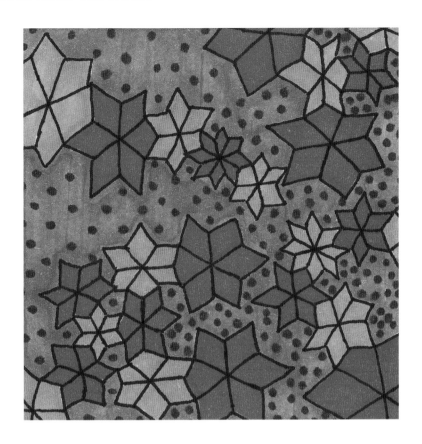

FLOWER CHAIN

The Flower Chain pattern grows quickly, so it is best to start with a tiny flower to allow the chain to grow without completely overwhelming the drawing.

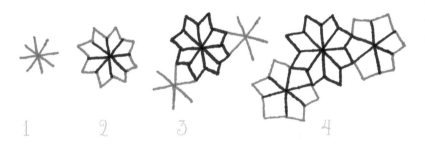

1 2 3 4

1 Draw four lines that intersect in the middle creating an asterisk.

2 Turn the asterisk into a set of touching diamonds by drawing a point between every two lines. This is your first flower. (This will be the only flower with four intersecting lines; the rest will be created with three intersecting lines.)

3 Starting at two points of the flower, repeat step 1, but using just three lines. Repeat.

4 Draw lines to connect the new asterisks into diamonds as done in step 2. Repeat the previous steps until you fill the space for this pattern.

5 Completed Flower Chain pattern.

5

Advanced Pattern
DIAMOND STRIPES

When practicing the Diamond Stripes pattern, make it larger than how you might use it in a drawing. This will help you better understand where the line placement and shading go in step 4.

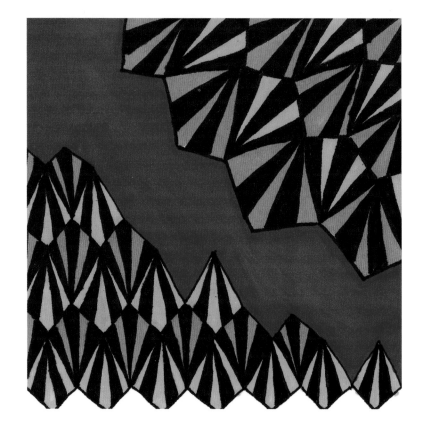

1 Draw a horizontal zigzag line.

2 Draw a horizontal zigzag line under the first line so the upper points of this new line touch the lower points of the first line. The lines of this zigzag line should be longer than the first zigzag line.

3 Draw more zigzag lines, making sure they touch the points of the previous line, until you fill your space. You should now have a series of connecting diamonds.

4 Starting at the point of the longer end of the diamond, draw four lines that extend to the opposite end of the diamond. Color in every other stripe.

5 Completed Diamond Stripes pattern.

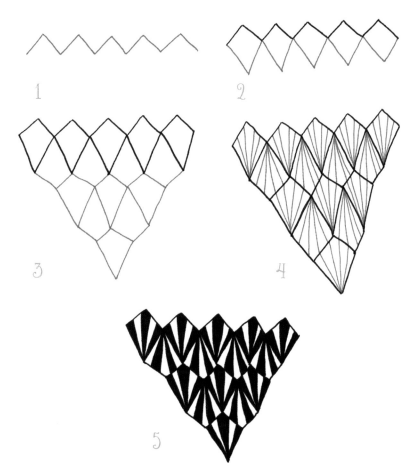

Sign up for our free newsletter at CreateMixedMedia.com.

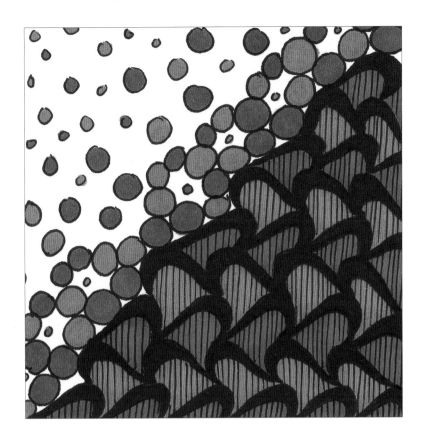

Advanced Pattern
FLIPSY FLOPSY

Use other filler patterns to fill in the space of Flipsy Flopsy for unique variations. This pattern is also great for practicing the blended Sharpie technique (see page 89).

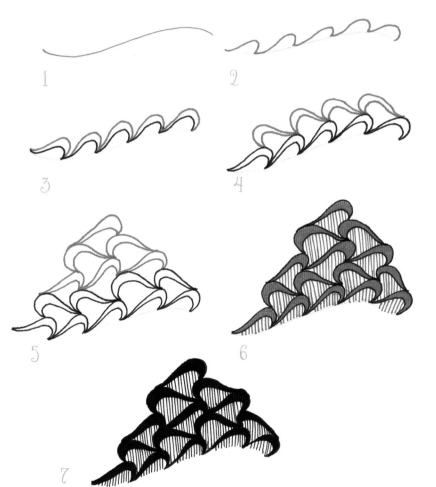

1 With a pencil draw a slightly wavy line.

2 Draw some half-heart shapes that connect end to end along the line.

3 Draw a second set of half-heart shapes that make the rounded part of the half-heart larger than the pointed end.

4 Repeat steps 2 and 3 to create more half hearts going in the opposite direction of the previous row. Each half heart of this row should begin and end on the rounded part of the half hearts of the previous row.

5 Continue making rows of half hearts until the space for the pattern is filled.

6 Color in the half hearts and draw vertical lines in all of the empty spaces.

7 Completed Flipsy Flopsy pattern.

Visit createmixedmedia.com/zen-doodle-unleashed to download free bonus materials.

53

Advanced Pattern
Center Wave

The Center Wave pattern can be somewhat tricky to create on a curve. Practice the pattern as a straight line and slowly work up to deeper curves.

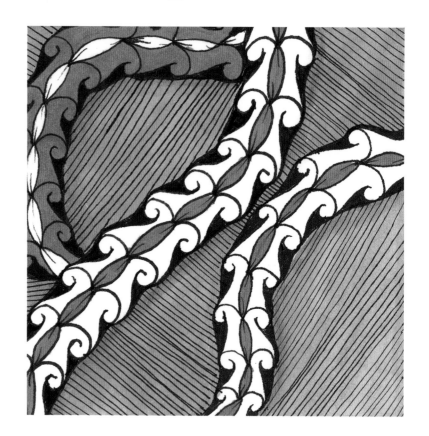

1 Draw a petal that is pointed on both ends.

2 Continue drawing petals under each other until you've reached the desired length. Add a flick in the middle of each petal.

3 Where the petals meet, draw a curve on either side with a dot on the end.

4 Draw a curve from the inner part of the previous curve to the outer part of the curve below it.

5 Draw a curve from the outer part of the original curve to the outer curve underneath it.

6 Color in the space created by step 5 to complete the Center Wave pattern.

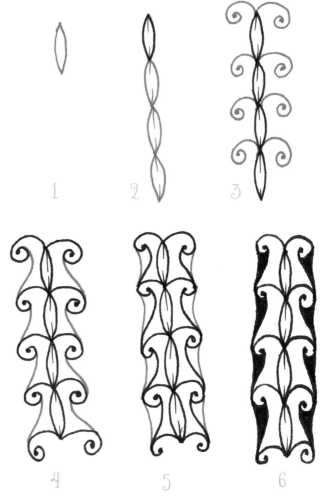

Sign up for our free newsletter at CreateMixedMedia.com.

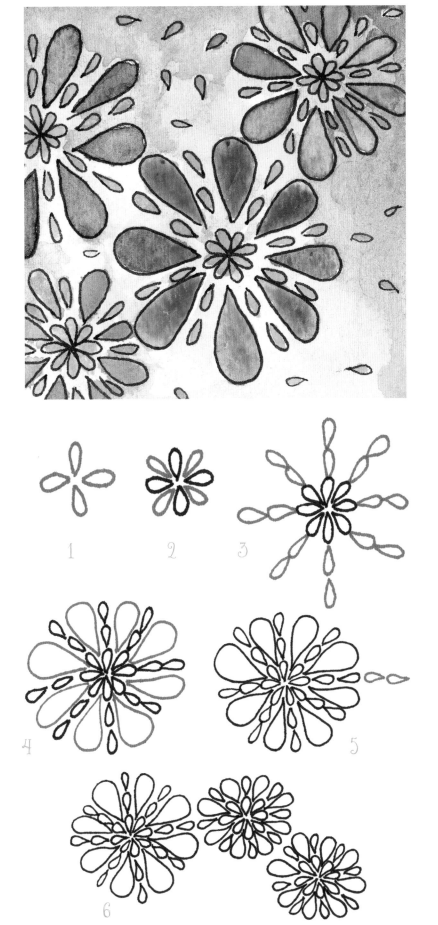

Advanced Pattern
DROP FLOWER

The Drop Flower makes a great focal pattern and can take up a lot of room on the page. The openness of the larger drops allows for easy variations and using the Sharpie blended technique on page 89.

1 Draw four petals evenly spaced that don't touch in the middle.

2 Add four more petals in between the last four petals so it resembles a daisy.

3 Draw two petals off each existing petal with the points toward the center.

4 Draw a large petal between each line of existing petals. This is your first Drop Flower.

5 To add more Drop Flowers, extend the line of smaller petals with the point in the opposite direction of the existing petals and follow the previous steps.

6 Completed Drop Flower pattern.

Advanced Pattern
CoNNECTeD

For the Connected pattern, be sure to draw the bumps in step 1 the same size and have the point line up in the middle as much as possible. Making the bumps and points different sizes will set the whole pattern off kilter.

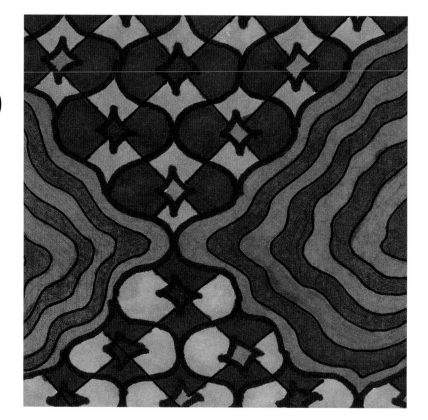

1 Using an 08 multiliner pen, draw a set of bumps that are similar to an upside-down Hershey Kiss shape.

2 Draw a second set of bumps above the first. The top point of this row should line up with the bottom points of the first row.

3 Continue making rows until the space designated for this pattern is filled.

4 Draw a diamond shape with the sides slightly concave inside all of the spaces.

5 Draw diagonal lines connecting the diamonds to each other.

6 Shade the left and right sections of the pattern to complete the Connected pattern.

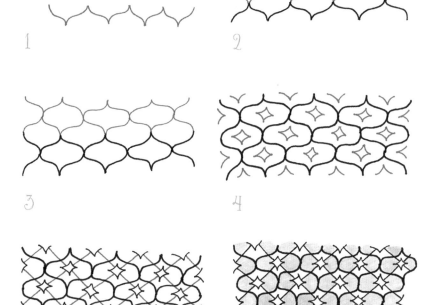

Sign up for our free newsletter at CreateMixedMedia.com.

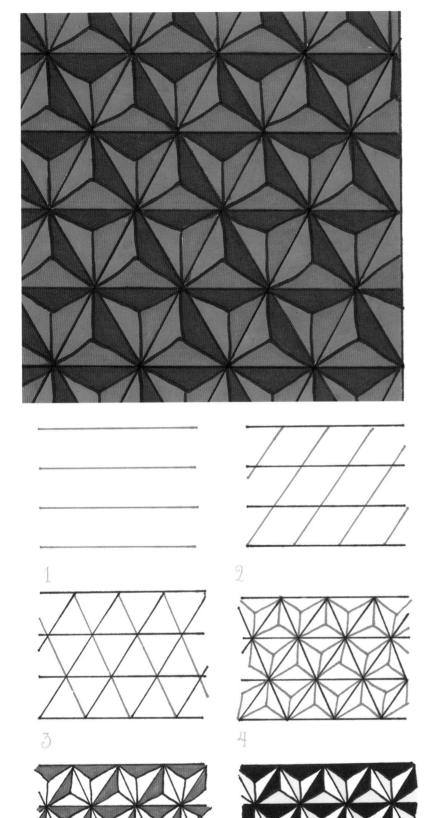

Advanced Pattern
TRi-STaR

The Tri-Star pattern can be a bit tedious and time-consuming. Be careful not to draw the horizontal lines in step 1 too close together or it will be difficult to complete the pattern. This pattern is best practiced on a larger scale.

1 Draw a set of horizontal lines that are evenly spaced, no less than ½ inch (13mm) apart.

2 Draw diagonal lines that are evenly spaced as much as the horizontal lines from step 1.

3 Draw diagonal lines in the opposite direction at the same spacing and angle as in step 1. The diagonal lines should intersect at the same point as the horizontal line. You should have a set of triangles.

4 Divide every triangle into three triangles with a Y shape. Some will be upside-down Y's.

5 Color in a section of every triangle in a repeating pattern. (What's shown is top, right, top, right.)

6 To complete the Tri-Star pattern, shade a section of every triangle in a repeating pattern. (What's shown is: left, bottom, left, bottom.)

Advanced Pattern
SKiPPY

Skippy is a great supportive pattern as it can be easily placed between any two patterns. A straight variation is shown in the colored tile at right.

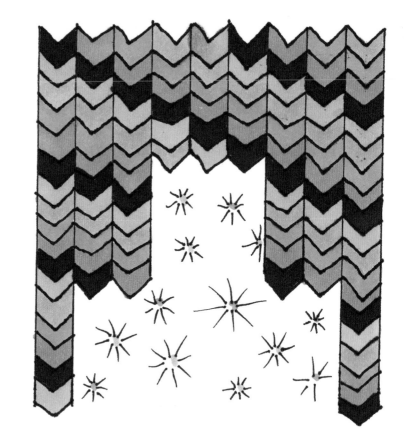

1 In pencil, draw several diagonal lines about ¼" (6mm) apart from one another.

2 Using a 02 multiliner pen, draw a diagonal line between all of the pencil lines.

3 Draw zigzag lines with points at each diagonal line.

4 To complete the Skippy pattern, erase the pencil lines and color in every other V shape.

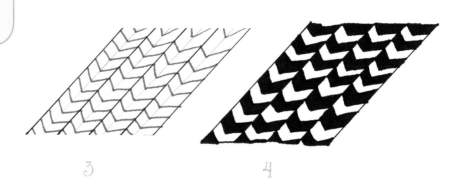

Sign up for our free newsletter at CreateMixedMedia.com.

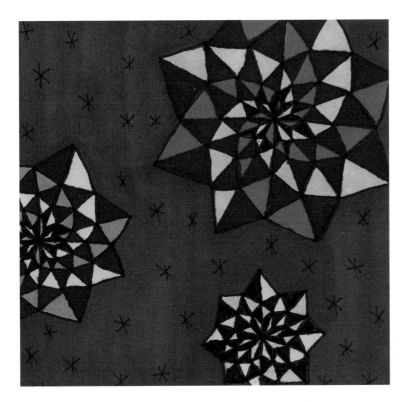

Geo Flower can take a bit of practice to master. Be careful not to put the first set of points in step 2 too close to the middle. This may make it confusing to color.

1

2

3

4

5

6

1 Draw four long lines that intersect in the middle. This should look like a large asterisk.

2 Draw a point between each line that is fairly close to the middle. This should make a set of connecting diamonds.

3 Draw a point that begins at the point of the previous row and ends at the line of the asterisk.

4 Continue to draw the points as in steps 2 and 3 until you reach the end of the original asterisk.

5 Draw lines that divide the diamond shapes into two triangles.

6 Color every other triangle until the Geo Flower is complete.

Visit createmixedmedia.com/zen-doodle-unleashed to download free bonus materials.

59

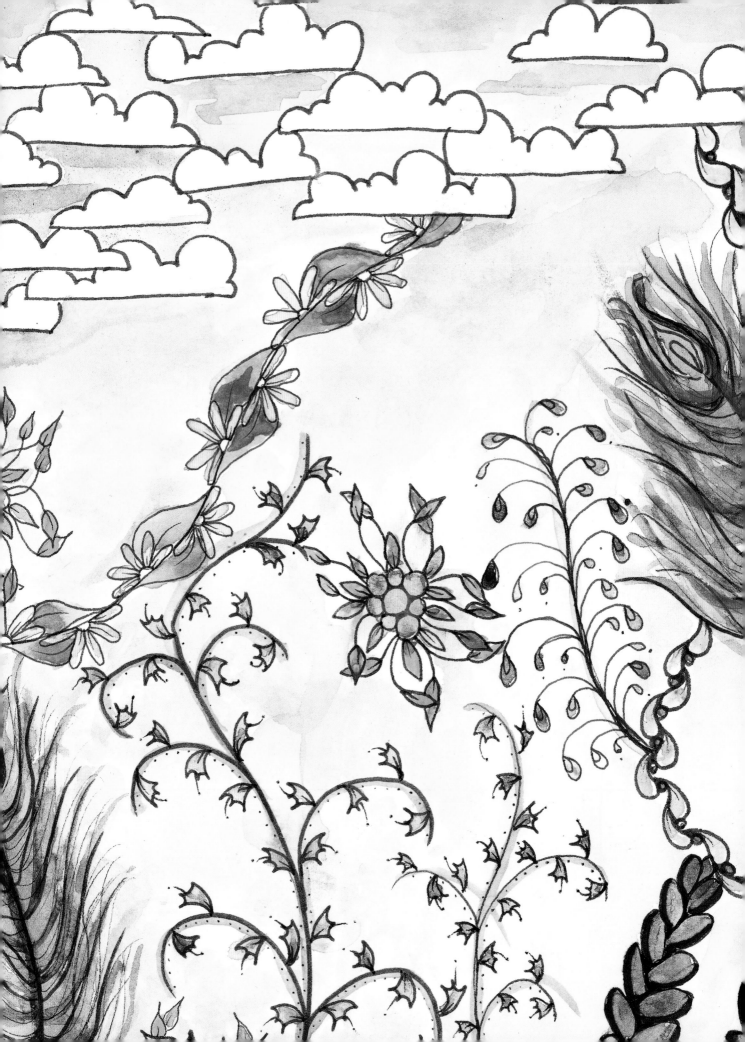

6

ORGANIC PATTERNS

Organic patterns are based on things you might see in nature. Tree bark, flowers and feathers, to name a few, have inherent natural patterns that translate well on paper. Most tangle patterns are of a geometric or abstract design, but organic patterns are dramatic and provide immediate contrast to draw the eye. For this reason, they should usually be considered a focal pattern.

Organic patterns also look great when using sketchy strokes. They don't depend on crisp lines the way some more geometric patterns do. With this in mind, organic patterns are great for people with unsteady hands.

When using organic patterns along with geometric and abstract designs, the balance of the drawing should be considered. Using a combination of too many of these patterns can quickly overwhelm a drawing.

On the facing page I used all organic patterns and colored the piece with watercolor paints. Watercolors work well with organic patterns because the shading is nice and natural. When practicing organic patterns, take advantage of the opportunity to also practice watercolor; just remember to use watercolor paper.

Organic Pattern
FLOWER LINES

Flower Lines is a great pattern to practice the sketch stroke to achieve a lovely organic pattern.

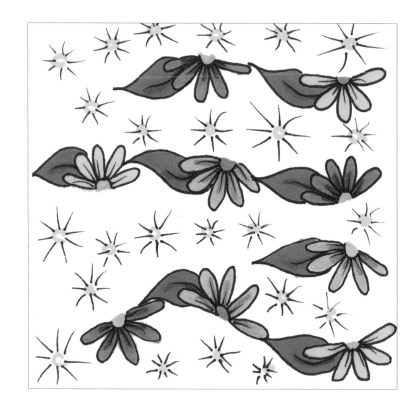

1 Using a pencil, draw a slightly wavy line.

2 Along the line draw a half circle with five petals. Add a flick stroke in each petal for a more dimensional look.

3 Draw a leaf from the right side of one flower to the next. Repeat between all of the flowers.

4 Completed Flower Lines pattern.

5 Variation: Add some upside-down flowers on the line.

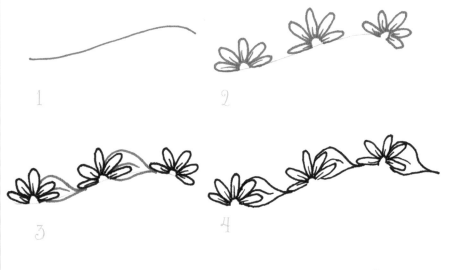

Sign up for our free newsletter at CreateMixedMedia.com.

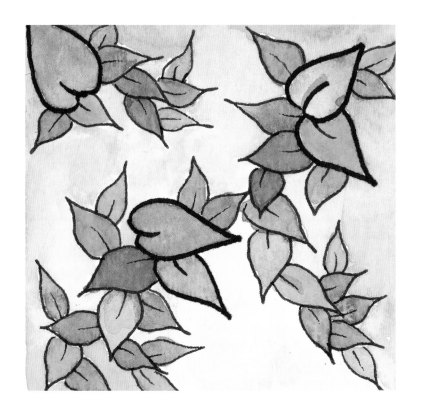

LOTS OF PETALS

Lots of Petals is a great way to practice changing pens to alter the perspective of the pattern. Using smaller pen nibs for smaller petals will make them appear farther away than petals created with a larger nib.

1 Using an 08 multiliner pen, draw a petal shape. Add a flick stroke to the petal.

2 Using other pen sizes, continue drawing petals overlapping each other.

3 To complete the Lots of Petals pattern, shade around each petal.

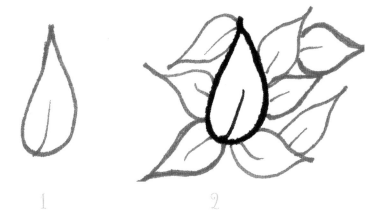

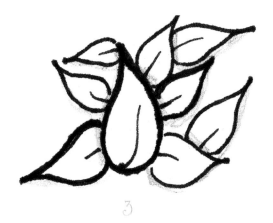

Visit createmixedmedia.com/zen-doodle-unleashed to download free bonus materials.

63

Organic Pattern
BLOOMIN'

When coloring the Bloomin' pattern, choose only two light colors. There's quite a bit of intricate detailing that can be easily covered by darker colors.

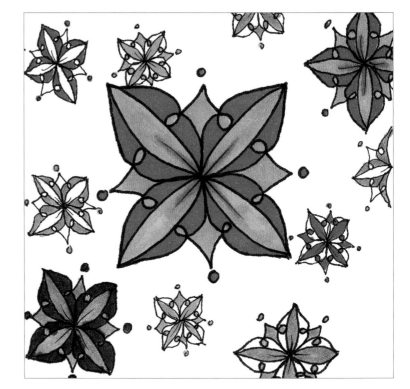

1 Draw four petals evenly spaced that meet in the center. Add a flick to each of the petals.

2 Around the edge of the petal, draw a curve that has a small loop in the middle.

3 Repeat step 2 on both sides of all the petals.

4 Draw a pointed line from the loop of one petal to the loop of the next petal. Draw a small circle over each point.

5 Completed Bloomin' pattern.

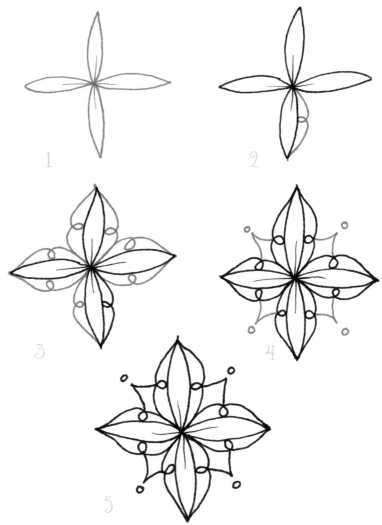

Sign up for our free newsletter at CreateMixedMedia.com.

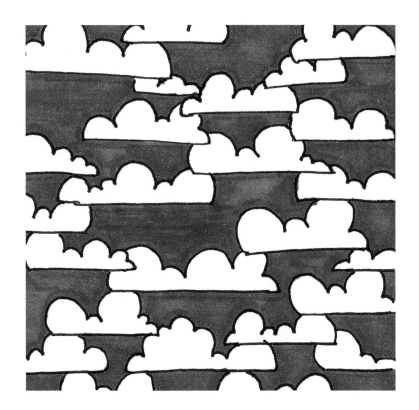

Organic Pattern
CLOUDS

Use shading at the end of each curve in the Clouds pattern to make it look more natural. You can also use different sized pens to change the perspective.

1 Draw several horizontal lines that are fairly close together.

2 Start from the top horizontal line and draw some bumps over the line to make a cloud shape. The bumps should vary in size and shape and make the clouds appear as though they are overlapping.

3 Completed Clouds pattern.

Organic Pattern
Leafing

Leafing is a great focal pattern that I use a lot to separate other patterns. Try tapering the size of the leaves to change the perspective.

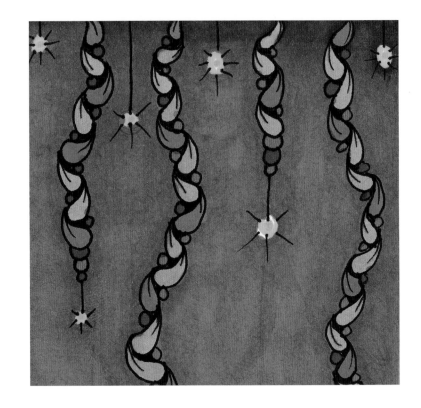

1 Draw a teardrop shape with the top of the shape curved slightly to the left.

2 Draw another teardrop shape under and to the left of the first. The top of the teardrop should curve slightly to the right so it touches the bottom of the first teardrop.

3 Continue the chain of teardrops until you've filled the space for the pattern.

4 Add a flick stroke to each teardrop to make it look like a leaf or petal.

5 Add a small circle where the teardrops meet.

6 Completed Leafing pattern.

7 Variation: To make the pattern wavy, use a pencil to draw a slightly wavy line before beginning step 1.

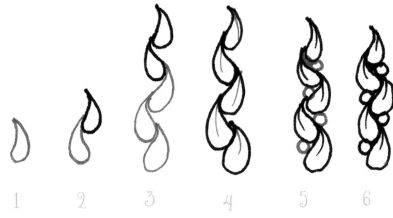

Sign up for our free newsletter at CreateMixedMedia.com.

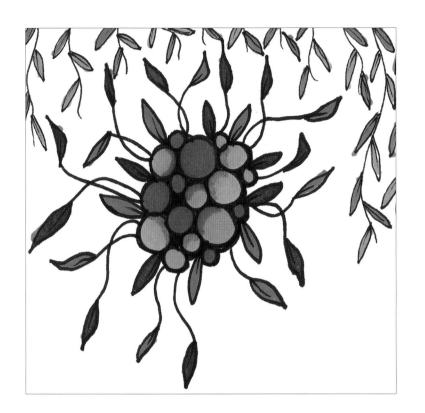

Organic Pattern
Berried Leaves

For Berried Leaves, use a flourish stroke when adding the stems in step 3 to achieve a natural flowing look to the pattern.

1 Draw a set of circles with the edges touching, and make one side of the circle slightly thicker.

2 Draw a small leaf shape on the outer edge where two circles meet and where there is a large enough gap to add a leaf on a single circle.

3 Draw a stem with a leaf shape at the end between the leaf shapes of the previous steps. Curve them slightly and allow some to appear as though they are overlapping.

4 Draw a small circle at the tip of every leaf where there is room and a flick on each leaf for added dimension.

5 Completed Berried Leaves pattern.

Visit createmixedmedia.com/zen-doodle-unleashed to download free bonus materials.

67

Organic Pattern
Bell FLOWERS

For the Bell Flowers, practice drawing the small flower shape before beginning the pattern. Practicing the shape beforehand will allow you to determine if the end result is what you desire. You can always change the shape of the flower as a variation.

1 Using a flourish stroke, create a wavy line.

2 Using more flourish strokes, draw a few curved lines off the original wavy line.

3 Draw small flowers that look similar to a duck's foot on either side of all the lines. Be careful not to place these too close together.

4 Using an 005 or 01 pen, add a tiny antenna that extends out of each flower with a little dot on the end.

5 Embellish the pattern by adding dots to the inner curve of the flourish lines.

6 Completed Bell Flowers pattern.

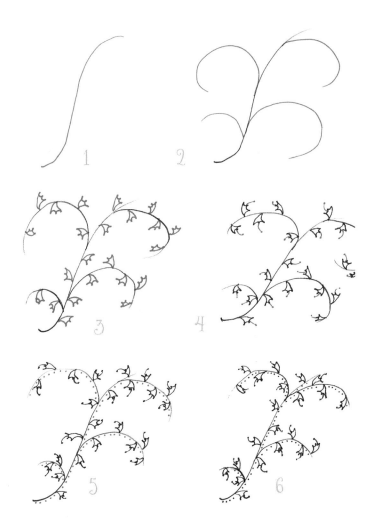

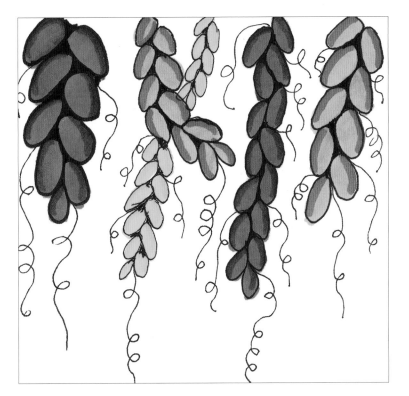

Organic Pattern

Asparagus Tops

Asparagus Tops is great for practicing different coloring techniques. The open ovals allow enough room to experiment blending and shading. This pattern also looks best when using a sketchier stroke to create a natural look.

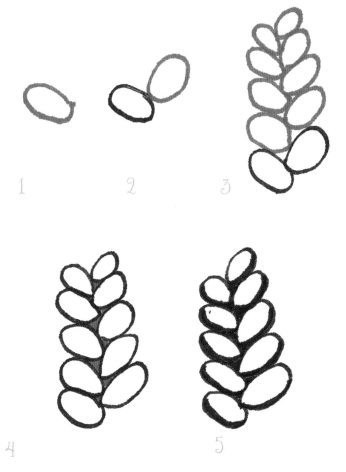

1 Draw a small oval that slightly leans to the left.

2 Draw another oval over the first, leaning this one slightly to the right.

3 Continue drawing a chain of ovals like this until you've reached the desired length.

4 Color in any empty space between the ovals.

5 Slightly darken the bottom edge of all the ovals to complete the Asparagus Tops pattern.

Visit createmixedmedia.com/zen-doodle-unleashed to download free bonus materials.

69

Organic Pattern
STOT

When placing several Stot patterns near each other, be careful with the overlap. When too many Stots are together, it can cause a confusing cluster of stems.

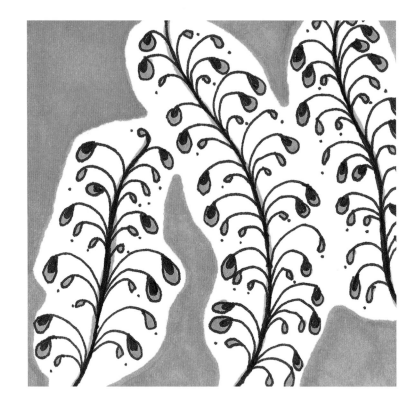

1 Using a flourish stroke, create a wavy line.

2 Draw three small lines that start very close to each other on the wavy line and curve them toward the bottom of the pattern. Add a small teardrop shape or double teardrop shape off the end of every line. Add a dot just outside the single teardrop shapes.

3 Continue drawing these three lines up the original wavy line until you reach the end. Vary the amount and placement of double teardrops for each set.

4 To complete the Stot pattern, darken the original wavy line slightly and color in the inner teardrop of all the double teardrops on the pattern.

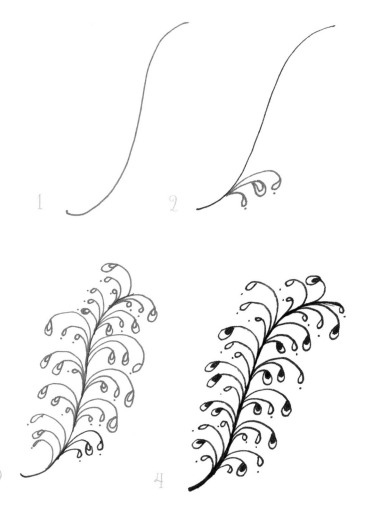

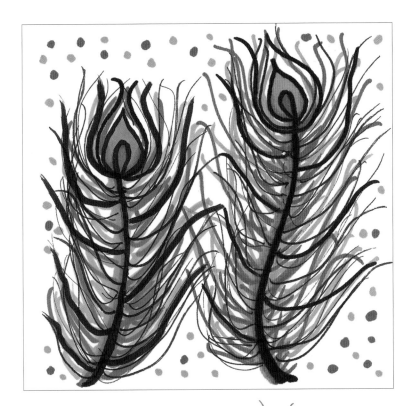

Organic Pattern
FEATHERS

In the Feathers pattern, remember to start from the bottom of the original line when adding your flourish strokes in step 3. Working from the top down will cause the bottom to be too wide to look natural.

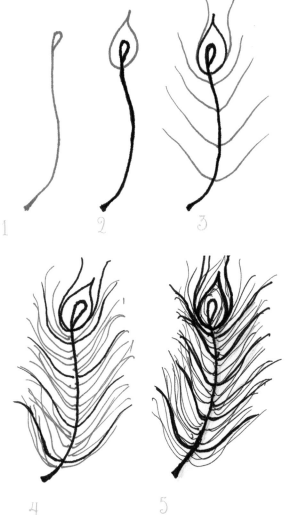

1 Using an 08 pen, draw a long, slightly wavy line with a small teardrop shape at the top.

2 Using an 05 pen, draw a larger teardrop shape around the teardrop from the first step.

3 Using a flourish stroke, draw some slightly wavy lines off the original line. Start from the bottom of the original line and work upward.

4 Using 02 and 005 pens, draw more flourish strokes. These should be done quickly, which will allow some of the lines to cross each other, giving the pattern a feathered look.

5 Completed Feathers pattern.

Visit createmixedmedia.com/zen-doodle-unleashed to download free bonus materials.

71

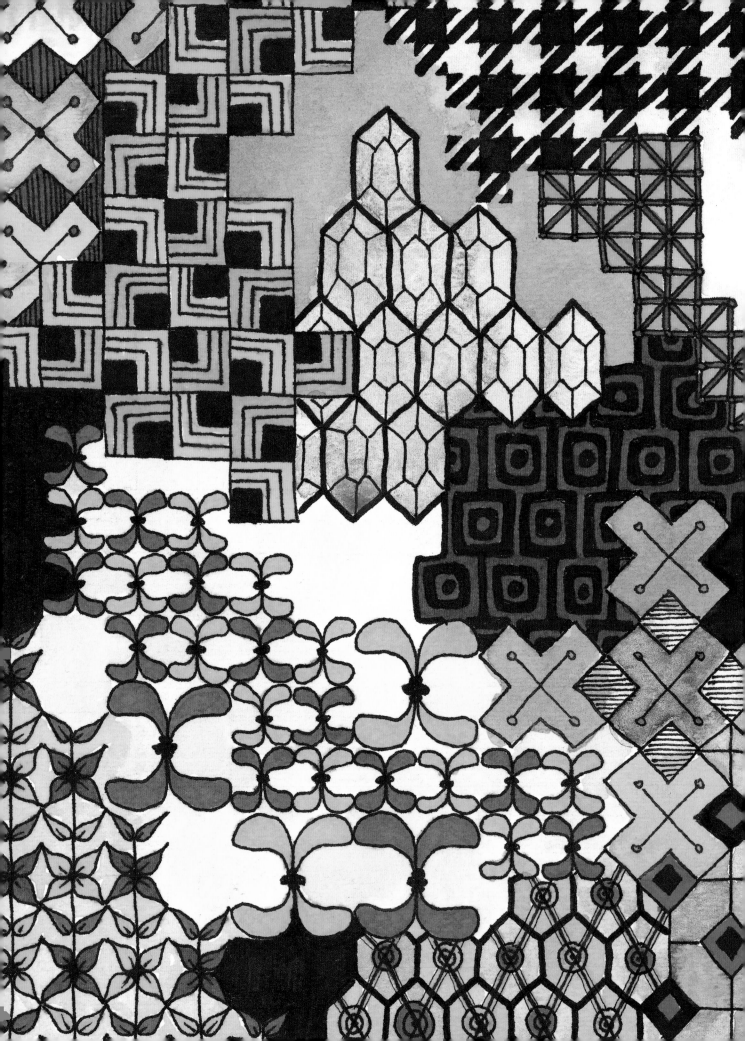

7

GRIDLINE PATTERNS

Gridline patterns always start with a grid in either ink or pencil. When you start practicing these patterns, it is recommended to use ¼-inch (6mm) graph paper. As you gain confidence, try drawing your own gridlines to work from. Patterns that start off with a pencilled gridline can be used as a guide and then erased later though that decision is up to you. Try using a very light stroke with your pencil so you don't leave any markings or depressions when you remove the gridline.

When creating a pattern with inked gridlines, you should use an 03 or smaller multiliner pen unless otherwise stated. Although the pattern may rely on a grid as a guide, it is usually not essential to have the grid be a featured part of the pattern.

On the facing page I created a tangle using only gridline patterns on watercolor paper. I used both watercolor and Sharpie markers to color the drawing. These patterns were all created with a ¼" (6mm) or ½" (3mm) grid. Try experimenting with different sized grids and see how this changes the perspective of the patterns.

When creating variations of the patterns, work off a ½" (13mm) or even ¾" (19mm) grid. This will make the patterns larger and more open to allow for adding details within the pattern. Note that there are two sizes of the LiLi pattern in the drawing. It is often easier to add more intricate patterns within the larger sized pattern.

Gridline Pattern
FLOWER WINDOWS

A ¼" (6mm) grid works well for this variation of the Flower Windows pattern. It will allow you to create 2" × 2" (5cm × 5cm) and 4" × 4" (10cm × 10cm) flowers without taking up too much space and overwhelming the drawing.

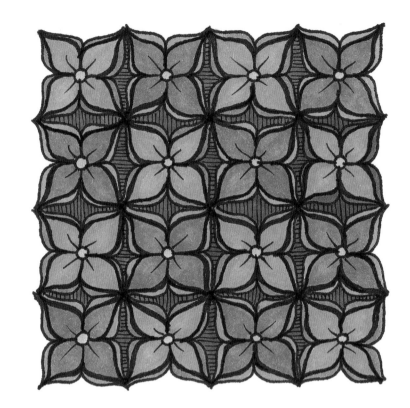

1 Draw a gridline in pencil.

2 Draw a small circle at every other intersection.

3 Draw four petals off each circle using the gridline as a guide for where your petals go. Add a small flick stroke within each petal.

4 To complete the gridline Flower Windows pattern, erase the pencilled gridline. Using an 005 pen, add a filler pattern in the spaces between the flowers.

5 Variation: Use the gridline to create different sized flowers.

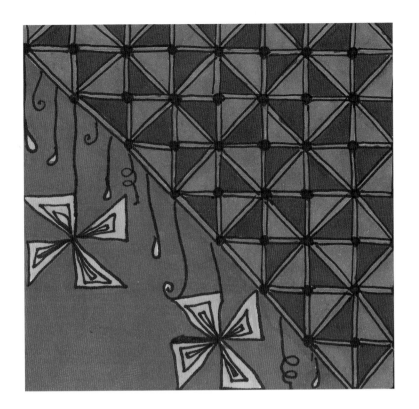

Gridline Pattern

XO was the very first pattern I created back in high school while doodling on ¼" (6mm) graph paper. Using a smaller sized pen like an 01 or 02 will help in creating the details of this pattern on a small grid.

1 Draw a gridline in pencil. Draw a small circle at every intersection on the gridline.

2 Connect every circle with double horizontal and vertical lines.

3 Inside every other square, draw a double diagonal line connecting the top left circle to the bottom right circle.

4 In the empty squares, draw a double diagonal line connecting the top right circle to the bottom left circle.

5 To complete the XO pattern, color in every other triangle.

Visit createmixedmedia.com/zen-doodle-unleashed to download free bonus materials.

75

Gridline Pattern
CORNERED

When creating the cornered pattern, if you have trouble making the squares the same size in step 2, create a smaller gridline and draw the pattern by coloring the correct square in a 2" × 2" (5cm × 5cm) block.

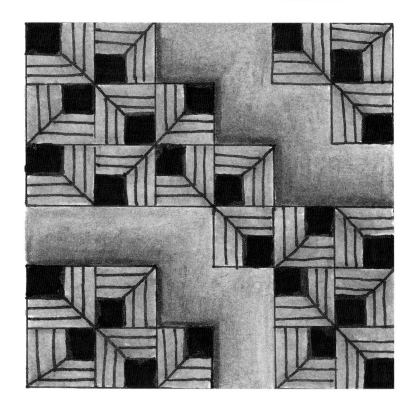

1 Draw a gridline.

2 In the top row of squares, put a small colored-in box in the top left or bottom left corners, alternating along the row. Continue this pattern in every other row.

3 In the remaining rows put a small colored-in box in the top right or bottom right, alternating along the row. These small boxes should touch corners with the small boxes from step 2.

4 Draw diagonal lines through the middle of the small boxes and continuing to the bottom of the gridline.

5 Draw two L shapes around each of the boxes, with the angle at the diagonal line of step 4.

6 Completed Cornered pattern.

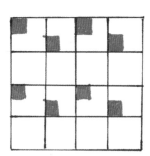
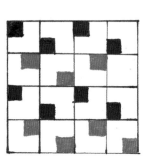
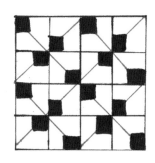
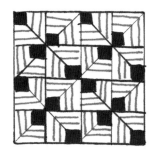
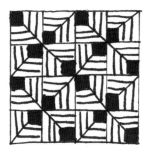

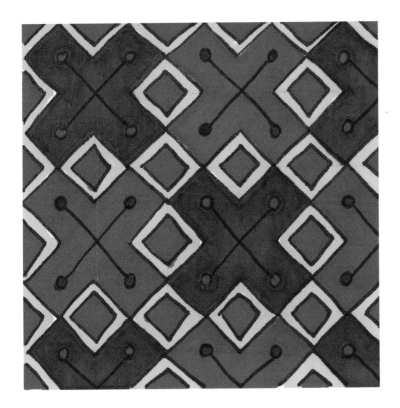

The Exes pattern can take up quite a bit of room. Practice on different sized grids to determine which size you like most.

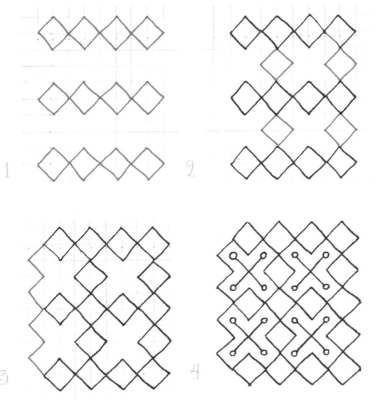

1 Draw a gridline in pencil. Draw a horizontal chain of diamonds using the grid as a guide. Skip two rows of the grid and create another horizontal chain of diamonds like the first. Continue this until you fill the space for the pattern.

2 Draw a diamond under every other diamond from step 1. This should create some open X shapes.

3 Draw a zigzag line on the edges to finish creating the X shapes. To finish the pattern, erase the gridlines and draw some embellishments inside the X shapes.

4 Completed Exes pattern.

Visit createmixedmedia.com/zen-doodle-unleashed to download free bonus materials.

77

Gridline Pattern
HOUNDSTOOTH

The Houndstooth pattern looks best on a ¼" (6mm) gridline, but I recommend practicing with ½" (13mm) grids at first. This will allow you to get a feel for where to place the diagonal lines to complete the pattern.

1 Draw a gridline with an 05 multi-liner pen. Starting in the second row of squares, color in every other square. Skip the next row of squares and color in every other square of the third row. Continue this until the rows are complete.

2 In the squares to the top, left, bottom and right of the black squares, draw four diagonal lines all going in the same direction.

3 Color in the space between every other diagonal line starting at the corner.

4 Completed Houndstooth pattern.

2

3

1

4

Toom

Toom requires a very small gridline drawn in pencil. Because of this, it's best to use this pattern in smaller areas of a drawing. The creation of the gridline is the most time-consuming process of the pattern.

1 Draw a gridline in pencil. Draw a diamond that starts at an intersection of the gridline, skips the next intersection and ends at the next intersection. Skip the next line and create another diamond at the next line. Continue until the end of the row.

2 Draw a diamond underneath and to the left of the diamond above it so this row of diamonds is offset from the previous row of diamonds.

3 Continue step 2 until the gridlines are full of diamonds.

4 Draw a smaller diamond inside each of the existing diamonds, coloring in every other smaller diamond on the row.

5 Color in the border around the smaller diamonds that are not colored in. Draw lines along the gridline connecting the points of the outer diamonds, and erase the gridline.

6 Completed Toom pattern.

Visit createmixedmedia.com/zen-doodle-unleashed to download free bonus materials.

79

Gridline Pattern
GEMS

Gems is another pattern that can take up a lot of room though this one doesn't have many options for variations. Practice with different sized gridlines to determine which size will work best for your drawing.

1 Draw a gridline in pencil. Draw a vertical line on every other line of the grid.

2 Connect the vertical lines with a zigzag.

3 Using an 005 or an 01 pen, draw a smaller hexagon inside every existing hexagon and connect the points with a small line. Erase the pencilled gridline.

4 Completed Gems pattern.

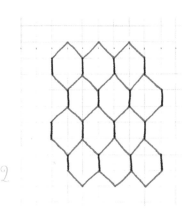

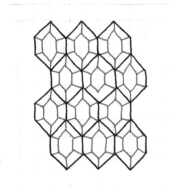

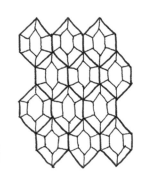

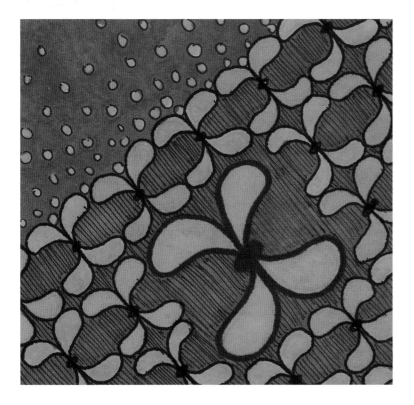

Gridline Pattern
LiLi

The LiLi gridline pattern has a lot of options for variations. Try placing different filler patterns between the LiLis or try a double teardrop shape instead of a single.

1 Draw a gridline in pencil. Draw a teardrop shape that starts at an intersection and has the wider end toward the top left of the square. (Note: There should be more room under the teardrops than over them.) Continue drawing this shape in every other square within the row. Skip the next row and continue drawing the same shape in every other square of the following row.

2 Draw a teardrop shape in the square next to the first teardrop shape but going in the opposite direction. Create this teardrop shape next to every teardrop from step 1.

3 In the rows that were skipped, draw teardrop shapes starting at the same intersection but with the wider end toward the bottom left or right of the square. Do this in every empty square.

4 Draw a small oval at the spot where the teardrops meet and color it in. Erase the gridline.

5 Completed LiLi pattern.

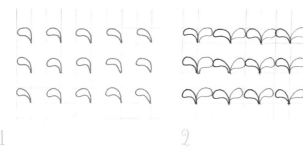

1

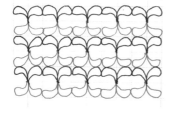

2

3

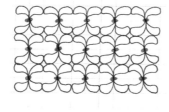

4

5

Visit createmixedmedia.com/zen-doodle-unleashed to download free bonus materials.

81

Gridline Pattern
Hex-an-X

The Hex-an-X pattern needs to be worked on about a ½" (13mm) gridline to allow for all extra details to be added without looking crowded.

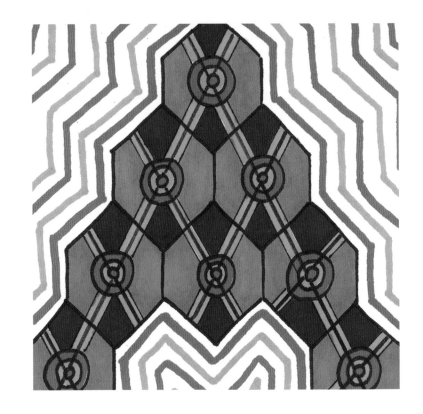

1 Draw a gridline in pencil. Draw a vertical line on every other line of the grid.

2 Connect the vertical lines with a zigzag.

3 Draw three small circles like a target inside each hexagon.

4 Connect all of the circles with three lines in a diagonal direction. The middle line should be slightly thicker than the outer two lines. Erase the gridline.

5 Completed Hex-an-X pattern.

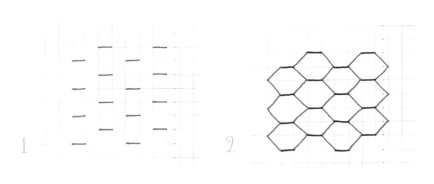

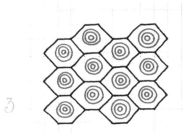

Squircle is a pattern that can be worked on any size gridline. Remember that your vertical lines will not stay on the gridline; only use the gridlines to help with spacing.

1 2 3

1. Draw a gridline in pencil. Draw a line along the grid that goes down two blocks, left one block, down two blocks, right one block, down two blocks, etc. until you reach the length desired.

2. Create a mirror image of step 2.

3. Repeat steps 1 and 2 until you reach the desired width. (Note that the farther right you go, the more the lines go off the gridline.)

4. Draw a circle and two squares with rounded edges inside each square.

5. To finish the Squircle pattern, erase the gridline and color in every other shape.

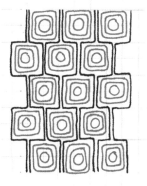

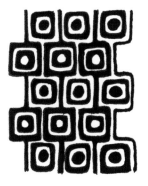

4 5

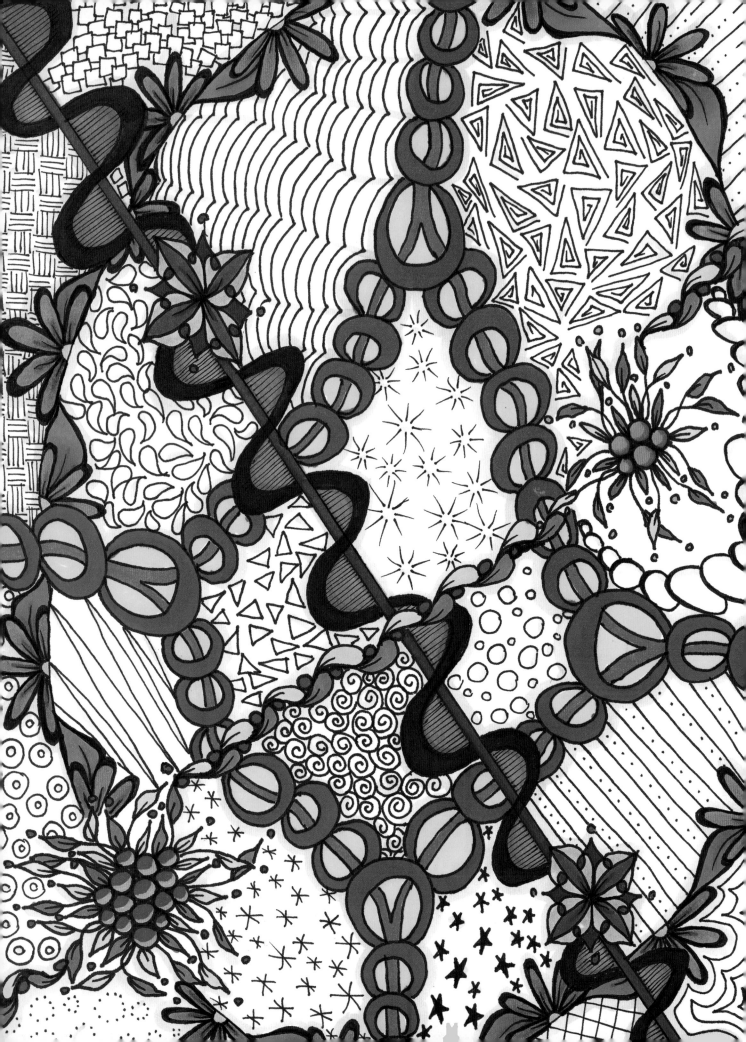

COLORING TECHNIQUES

Adding details by coloring and shading is an essential part to creating a freeform tangle. Your drawings can have a completely different impact simply based on the way they're shaded or colored. It can take time to really master the techniques, but it's well worth the effort to learn.

In this chapter, we discuss the basic techniques of multiple mediums including graphite, permanent marker, colored pencil, watercolor and oil pastels. The instruction is intended for the beginner. Working with an unfamiliar medium requires practice and experimentation, which is an ongoing process.

Before you can master shading and coloring, it helps to understand the basics of value and the color wheel. I often go against what is typically acceptable in color and shading because I feel inspired to do something different. In other words, it's important to learn the rules before you can break them!

The most important thing to remember when adding color to one of your drawings is to just go for it. It took about six months before I had the courage to add even a little color to my drawings. I was afraid of getting it wrong, so I tried to stay away from it. When I started adding shading and experimenting with color, I quickly realized how much of an impact just a little bit of color can have on a drawing. While there are specific guidelines to shading and selecting your palette, try not to limit yourself to the norm if you're feeling inspired to use colors that don't necessarily go together. For instance, the gridline drawing I created on page 125 uses purple and orange. These colors aren't typically seen together, but that's what I was feeling inspired to use at the time, so I went with it.

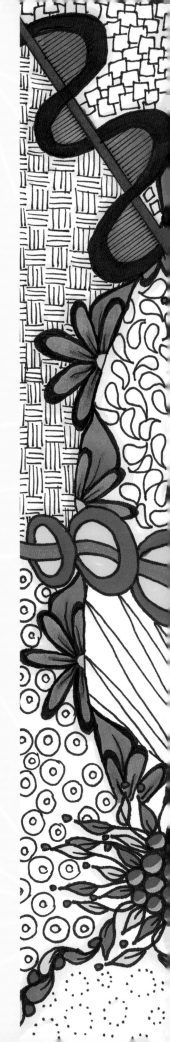

SHADING WITH A PENCIL

Shading in a freeform tangle is a bit different than a traditional shading technique because tangle designs are so abstract. However, it's still best to have a basic understanding of shading to help you determine the best place for shading your patterns and designs.

3 Simple Shading Techniques

There are many ways to choose how light or dark to shade a drawing after you have determined where shading needs to be added. Here are three simple methods:

Simple overlap—Imagine that the patterns of your freeform tangle are thin building blocks that lie on a white table, overlapping one another. The shading tends to be at the edges of each block (or pattern) and a bit on the block itself. You also will have consistency in the darkness of the shading.

Piling—Now imagine that the building blocks are piled on top of each other to make a mountain. The shading is lighter (or even nonexistent) at the top of the mountain and gets darker as you go down the mountain. Determine where the peak of the mountain is and let the shading gradually become darker as you work outward toward the edges of the page. A good tip for this type of shading is to choose the center of one of the focal patterns to be the peak of the mountain to help draw the viewer's eye.

Hole shading—This is simply a reverse of the piling method. Choose a pattern on the page to be the deepest part of the hole. The shading will be lightest around the edges of the page and gradually become darker as the hole gets deeper.

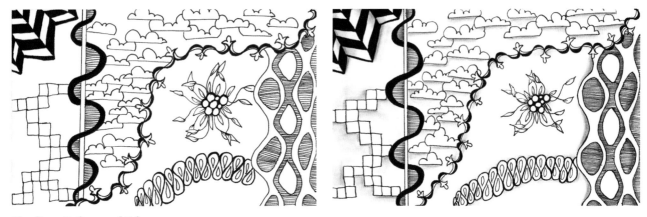

Shading: Before and After
For freeform tangles, aim to place your shading where it will look good, and try to keep it consistent for each section of a particular pattern. Shading is mainly used to add depth and perspective among different patterns. You always want to shade where patterns touch each other so they appear to be overlapping.

Understanding Your Light Source
The rules for shading state that if the light source is coming from the top left of your page, the darkest shading should be at the bottom left of the page and gradually become lighter the closer objects get to the light source. When you look at most freeform tangles, it is usually not apparent where the light source is coming from, so a good rule of thumb is to keep your shading consistent.

Sign up for our free newsletter at CreateMixedMedia.com.

CREATE A SIMPLE VALUE SCALE

Understanding how different pencil grades work on different paper will take you far. A great way to experiment with pencil grades is to a create a simple value scale before you apply your shading. I've found that a 4B shading pencil works best for most shading on standard 110-lb. (230gsm) cardstock. But a 2B or even an HB can work well in smaller, more detailed areas.

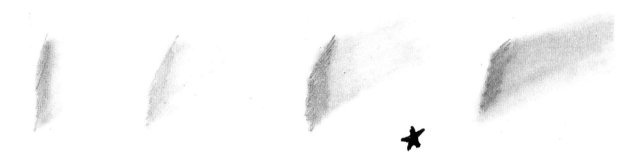

1 Create a Simple Value Scale to Test Your Pencils

Select a piece of 110-lb. (230gsm) cardstock or whatever type of paper you will be drawing on and draw 1-inch (3cm) blocks equal to the number of pencils you want to test. Here I am testing four pencils: HB, 2B, 4B and 6B. The blocks should be about an inch (25mm) in size. Pressing down naturally, draw a line in one of the boxes for each of your pencils, and then take your blending stump and blend out the line as far as it will naturally go. Use a clean blending stump for each line so there's no leftover graphite from pencil to pencil. After each line is blended, choose which blending look you think will work best for your drawing and mark it with a star.

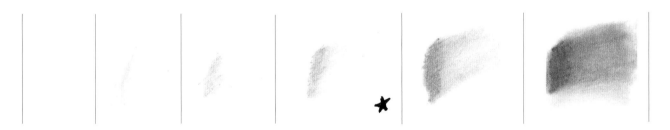

2 Create a Value Scale for the Best Pencil

Once you have selected the best pencil (such as a 4B), draw another set of five or six 1-inch (3cm) blocks to create a value scale for just this pencil. Leave the far left block empty to represent the least amount of shading that can be created in a drawing. Create the lightest pencil line in the next box, and continue pressing harder until the boxes are filled. Take a blending stump and blend each of the pencil lines in the boxes. This is your value scale for your pencil. I like to place a star in the box that contains my natural pencil stroke to help me determine how hard to press in the drawing to achieve the same shading as represented in the value scale.

Visit createmixedmedia.com/zen-doodle-unleashed to download free bonus materials.

87

THE COLOR WHEEL

Color is not necessary for freeform tangles, but it is a great way to add interest. The color wheel is a highly useful tool for learning which colors work best together. It is made up of the three primaries (red, yellow, blue), three secondaries (orange, green, violet) and six tertiary colors (red-orange, yellow-orange, yellow-green, blue-green, blue-violet and red-violet).

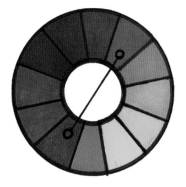

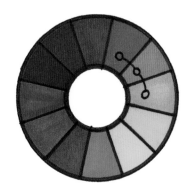

Complementary
Colors that are across from each other on the wheel—red/green, blue/orange, yellow/violet—are complementary. They work well together but can be overwhelming in large areas. They are best used in small sections to help that area pop from the rest of the drawing.

Analogous
Choose three or four colors next to each other on the wheel for an analogous color scheme. As with complementary colors, using these on a large piece of art can cause the colors to fall flat.

Triadic
Three colors that are evenly spaced around the wheel are triadic. When using this color scheme, let the two darker colors dominate the drawing and use the lightest color as an accent to highlight specific areas.

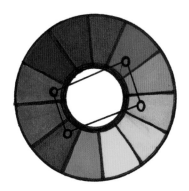

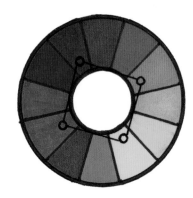

Split-Complementary
This is a variation of the complementary wheel using two colors from one side of the wheel and one opposite. Although the two-and-one combination is contrasting, the effect is more subtle and pleasing to the eye and helps create balance.

Rectangle Combination
For this combo select two complementary pairs forming a rectangle on the color wheel. When using this type of scheme, allow one color to dominate and use the other three as accents.

Square Combination
This combo is similar to the rectangle scheme, but the colors are evenly spaced around the color wheel to form a square. Let one color dominate the drawing and use the other three as accents but sparingly. This scheme can be quite dramatic.

Sign up for our free newsletter at CreateMixedMedia.com.

PERMANENT MARKER

To blend Sharpie markers, use new or almost new markers because these have the most ink. Choose two shades of the same color. Draw a line of the darker color. While the ink is still wet, take the lighter shade, and using a circular motion, color over the darker color and right next to the darker color. This will allow the marker to pick up the darker color and blend out beyond that line with the lighter shade. Next, still using the lighter color and a circular motion, blend to the outer edge without touching the darker color. This will create a three-color blended effect.

Sharpie Freeform Tangle
This process of blending Sharpies can be somewhat time-consuming, so it's recommended for small areas. This method is great for accenting focal patterns.

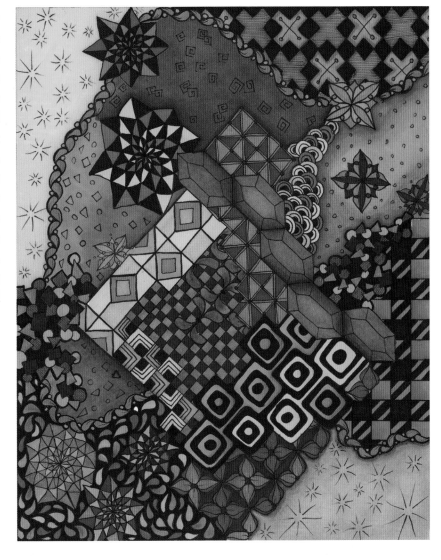

Sharpie Blending Method

Visit createmixedmedia.com/zen-doodle-unleashed to download free bonus materials.

89

COLORED PENCILS

To blend colored pencils, select multiple shades of the same color. Apply the darkest shade first. Use the same pencil to gradually shade outward until you reach the edge of the design. Select the next lightest colored pencil and follow the same steps as you did with the darkest pencil to blend the colors. Continue adding color until the desired look is achieved.

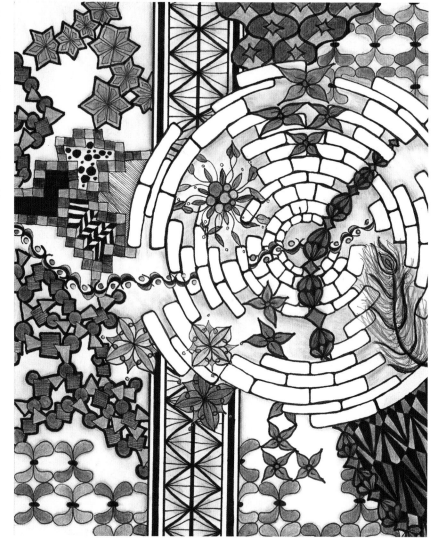

Colored Pencil Freeform Tangle
This drawing was colored with blue and purple shades of Derwent Inktense pencils and shaded with a 4B pencil. The colored shading was created by overlapping and blending the pencil shades. This can be a tedious process, but the result is much more exciting than if I had not blended the pencil shades.

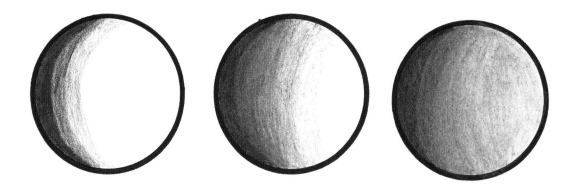

Colored Pencil Blending Method

OIL PASTELS

To color with oil pastels, choose two different shades of the same color. Take the darker shade and make a mark of color. Next take the lighter shade and make a mark near the darker color. Take a blending stump and move it in a circular motion to blend the colors together over the entire area. Your hands will quickly get dirty with pastel residue when you blend. Keep some baby wipes nearby to wipe your hands when you switch colors. Avoid using your hand to wipe away residue because this will smear the color. Instead, shake the paper over a garbage can, and the residue should come off.

Oil Pastel Freeform Tangle
This piece was colored using the oil pastel technique described above. The end result is softer than colored pencils. Allowing the white of the paper to show through the lightest part of the blended pastel helps to create a nice, soft look.

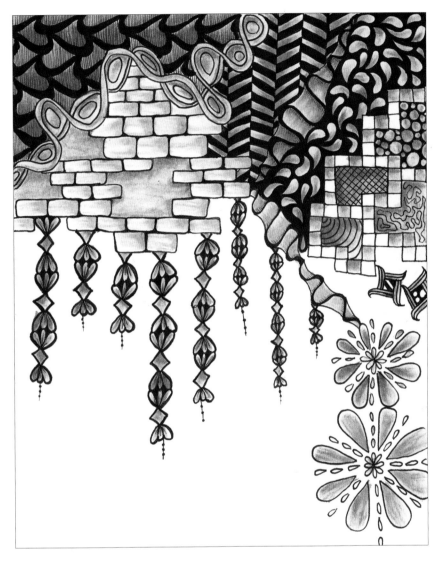

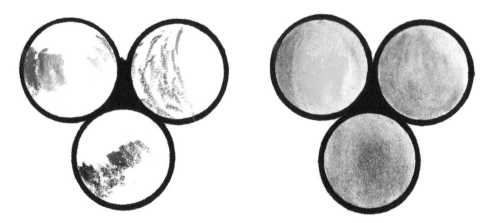

Oil Pastel Blending Method

Visit createmixedmedia.com/zen-doodle-unleashed to download free bonus materials.

91

WATERCOLOR

There are many ways to add watercolor to a drawing, but here I cover the easiest method. Here are the basic supplies you need to get started:

- masking tape
- waterproof pens or markers
- warm water to clean the paint from your brush
- cold water to load the brush with before picking up paint
- paper towels for dabbing the brush clean
- brushes and paints
- watercolor paper

To start, tape down the borders of your paper with masking tape to prevent it from rippling when wet. Make sure to draw your tangle with a waterproof pen or marker so it won't bleed when water is applied.

Dip a clean watercolor brush into cold water and then load it with the desired amount of paint. Note that a very minimal amount of paint is required. More can be added if needed, but it's difficult to remove paint that is already on the page. Paint lots of color at first and then blend out with your brush to create an even fade of color.

Between each application, wash your brush in warm water, blot with a paper towel, wash again in cold water and blot with a paper towel again. At this point the brush should be clean enough to dip into a second cup of fresh cold water to load before picking up your next color.

If the color is lighter than desired, allow the paint to dry and add a second coat of the same color to the area.

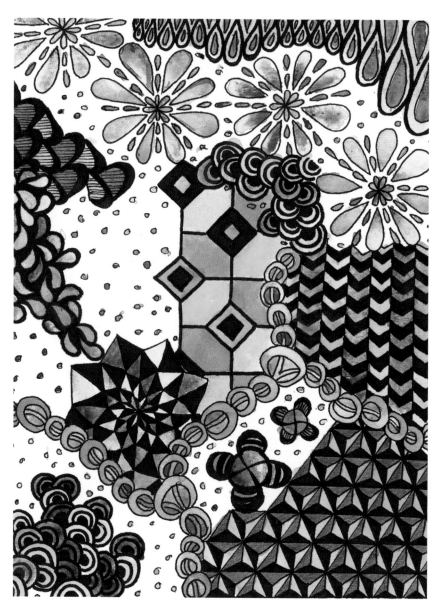

Watercolor Freeform Tangle
If you discover that watercolor is your preferred method of adding color, a number of excellent resources are available to help you develop different watercolor techniques.

MIXING COLOR TECHNIQUES

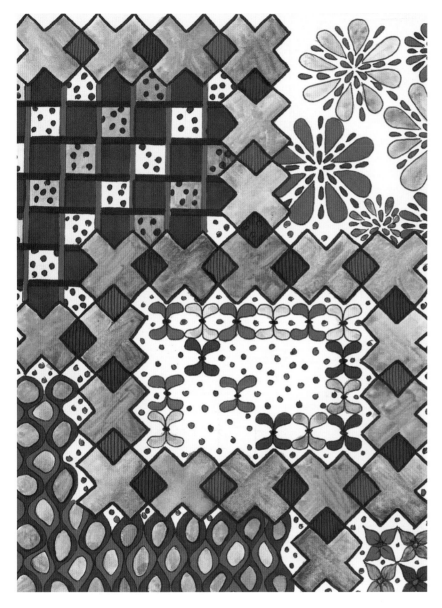

Practice combining different color techniques to create visual interest in your freeform tangle. If you plan to use watercolor, make sure the drawing is done on watercolor paper. You can use markers and pastels on watercolor paper in the same way you would cardstock though it may take a bit more effort to achieve the desired result.

Mixed-Media Freeform Tangle

When combining coloring techniques, it's best to use only two or three different methods on the same page. Allow one method to dominate and the others as accents to highlight particular areas of the drawing. Choose methods that have a drastically different appearance such as watercolor and oil pastels.

It also helps to choose just one color for each accent method and one color for the main coloring method. This will give the overall composition of the tangle a much more dramatic look. Here the boldest shades were colored with red and blue Sharpie markers, and the lighter shades were painted with various mixtures of water, Royal Blue and Crimson Red watercolors.

Visit createmixedmedia.com/zen-doodle-unleashed to download free bonus materials.

93

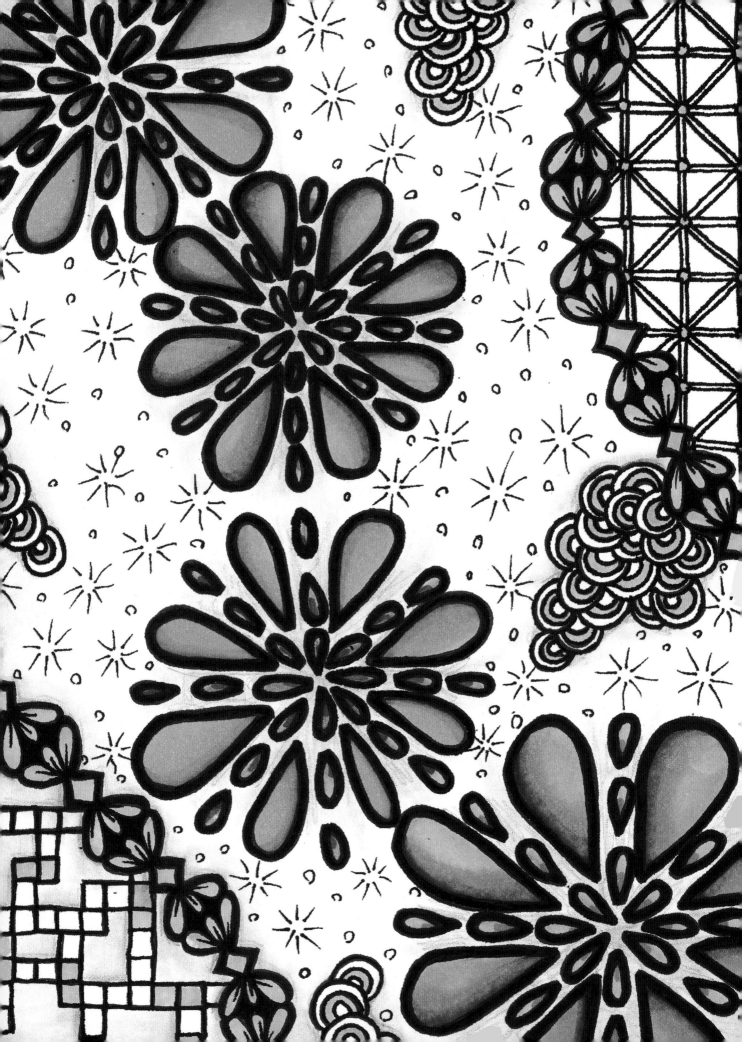

9

BUILD A FREEFORM TANGLE

After practicing different patterns, shading and color techniques, the hardest part of learning to freeform tangle is over. Actually drawing a freeform tangle is simple and can be done in a few steps. It's best to learn the basics of building a freeform tangle in steps to get an understanding of the purpose of the pattern placement.

A basic freeform tangle drawing is completed in three steps before adding shading and color. Focal, then supportive, then filler is the order the elements are added to the page. Remember that any pattern other than filler elements can be considered a focal point to a drawing.

Once this process is understood, you can work the drawing by mixing the order the patterns are added to the page and making the drawing appear as complex as desired. Mixing the order is sometimes necessary when intertwining patterns and elements. For example, in the colored pencil drawing on page 90, the circular Bricks pattern is the focal element. However, this pattern could not be created all at once. If it were, the Daisy Diamonds and Esses patterns could not appear as though they are weaving through the Bricks.

Demonstration

BUILD A FREEFORM TANGLE FROM SCRATCH

Everything about a freeform tangle consists of steps: the patterns, the assembly, the shading and the coloring. No matter how complex a freeform tangle looks, it can be broken down into steps. Once you understand the steps involved, you'll be able to decipher the order in which filler elements were added and how to duplicate the principles of a specific drawing. Don't feel locked into always creating a freeform tangle the same way. Freeform truly means freeform in this art form.

1 Draw the Focal Pattern

With a pencil or technical pen, place a few Drop Flowers (page 55) on the page for your focal pattern. If you start with a pencil, trace over the marks with pen when you are satisfied with the design.

This first step can be the most difficult because it's not always easy to choose a pattern when you have so many choices. It's common to stare at a blank page and wonder where to start. This usually happens because you are simply overthinking the process. If you get stuck, try one of these three tips to select your focal pattern:

1. *Start with your favorite pattern.* If it's a favorite, you have probably practiced it many times, and it can be drawn easily and quickly.

2. *Close your eyes and randomly point.* Use the pattern booklet in the back of this book or another collection of patterns you keep nearby. This may not be a very technical way of choosing what will be the focal point of the drawing, but it can be effective when you are at a loss.

3. *Pick an organic pattern.* Organic patterns are always focal patterns, so choose one that inspires you.

What matters most about the focal point is not how it's chosen but that something is down on paper. There is nothing more intimidating than a blank page, so don't let it stay blank for too long.

2 Add Supportive Patterns

Once one or more focal patterns have been established on the page, choose some supportive patterns that contrast well with the basic design. Here I chose four. Daisy Diamonds (page 42) creates the boundary for the Crossword (page 27) in the lower right, and the XO (page 75) in the upper right. The center of the drawing was looking a little empty for my taste, so lastly I added Peek-a-Boo (page 31) to complement the rounded look of the Drop Flowers. If I had selected a complex gridline pattern for the focal point, it would be good to select very basic patterns as the supportive element closest to the focal pattern.

Add many different supportive patterns to the drawing so your page is practically filled. Change the pen size often so it naturally creates more depth and perspective. Don't limit a pattern to one specific area. Make patterns overlap and intertwine with one another. Intentionally leave gaps within the supportive patterns so other patterns can show through later. This doesn't need to be done with every single pattern on the page, but do it at least a couple of times or more depending on the size of the drawing.

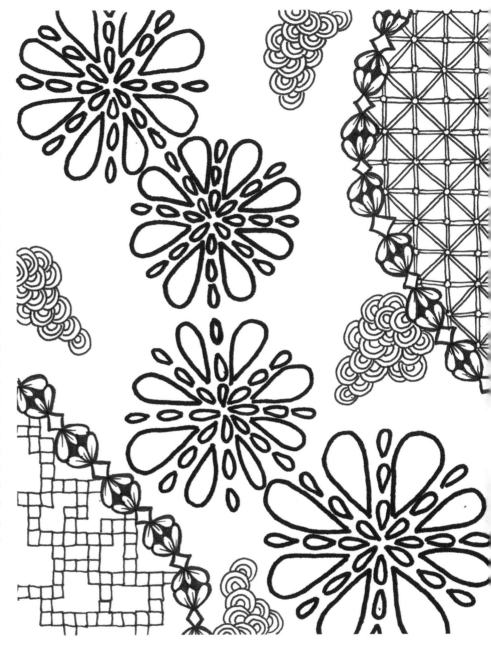

Edge to Edge

All patterns that near the edge of the drawing should go off the page. The design should look like it could go on forever if only you had more paper. Don't let the edge of the paper be a harsh ending to the drawing. This is a very common mistake when creating a freeform tangle. Making patterns run off the page allows anyone who looks at the drawing to imagine how it might continue.

Visit createmixedmedia.com/zen-doodle-unleashed to download free bonus materials.

97

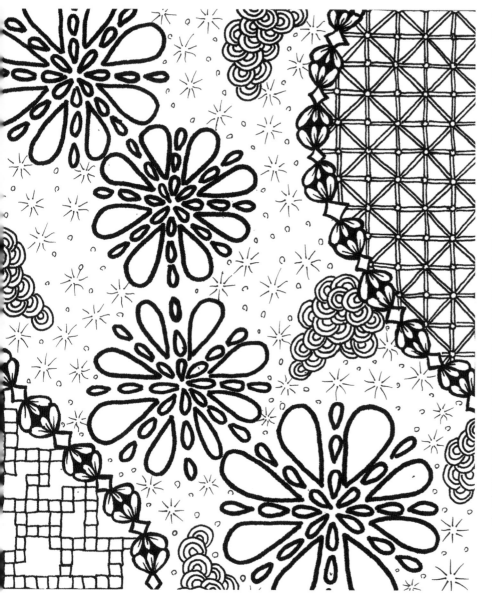

3 Add the Filler Patterns

Once the page is filled with focal and supportive patterns, choose a few filler patterns to add into any empty spaces. Filler patterns should be created with very small pens such as 005 or 01 Micron pens. This will allow the patterns to fade into the background.

Choose patterns that complement the basic designs surrounding the area. Here I chose the filler patterns that look like little starbursts along with little circles. I didn't want to use too many filler patterns in this drawing because of the simplicity of the focal pattern. Both of these patterns have a similar shape to the Drop Flowers and using a fine 01 pen allows these filler patterns to fade into the background and simply be seen as an accent to the drawing. For example, if there are several patterns that have a rounded shape, choose a filler pattern with a rounded appearance. Using a filler pattern that contrasts too much with the supportive and focal patterns can be distracting and will cause the filler patterns to become the focal point instead. This is not ideal because filler patterns are too simple to be the focal point.

Dos and Don'ts of Filler Patterns

Filler patterns should fade into the background while bridging the gap between the surrounding patterns. They should not take more than two steps to complete, they need no shading and they should not cover more than about 1½ inches (4cm) of any one area. Once filler patterns are added, forget about them. Shade and/or color right over them without a second thought because that will help them fade into the background.

4 Shade and Color the Drawing

At this point the freeform tangle might look a little flat and uninteresting even with all the patterns and pen sizes used. This is perfectly normal and you should not feel discouraged. Shading and coloring bring the drawing to life and make everything visually interesting.

Add shading around the edges where any supportive patterns touch each other or touch a focal pattern. Also add shading to increase depth or perspective. Remember to keep the shading of each pattern consistent and to blend with a blending stump for larger areas and a tortillion for more intricate details.

See page 94 for the finished color version. Coloring is the final step of creating a freeform tangle. Deciding how much or how little color to add to a drawing is all a matter of preference. If a lot of color is desired, remember the basics of the color wheel to keep the colors balanced. When adding only a few highlights of color to specific areas of a drawing, choose a bright or unique color to immediately draw the eye. Red is a good option for sporadic color and probably the most traditional, but consider also using coral, lime, light turquoise or a purplish pink. These more unusual colors will create deeper interest in a drawing.

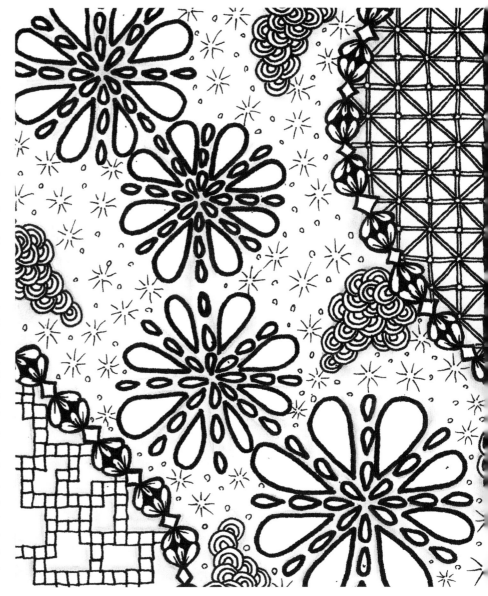

Create Contrast with Coloring

The three shading methods discussed on page 86 can be applied to color as well. When adding color, be careful not to add dark colors over intricate patterns. This will cause some of the more detailed and beautiful aspects of the drawing to fade into the background. If you have a complex pattern in an area that needs to be heavily shaded with color, choose a darker shade of a brighter color such as two shades of yellow. Just be sure to use its brighter counterpart in the lighter areas of shading to add contrast.

Visit createmixedmedia.com/zen-doodle-unleashed to download free bonus materials.

99

SHE TURNED HER CAN'TS INTO CANS AND HER DREAMS INTO PLANS

10
LETTERING

I recommend learning simple lettering techniques to take your freeform tangle to a different level. Simple lettering allows you to spice up greeting cards, labels, gifts and more.

In this chapter you learn two simple ways to add lettering to a design: basic capital letters and stencils. I decided on these two basic lettering techniques because they are easy for anyone to replicate. I've always been intimidated by the complexity of calligraphy but have wanted to add text to some of my designs especially when I am drawn to a particularly memorable quote. A simple font in capital letters or block stencils is the perfect match for freeform tangles. Anything more complex may take away from the beauty of the drawing and patterns surrounding the words.

When using lettering within your freeform tangles, remember to always start with the lettering first. This will ensure that you have enough space for the phrase you wish to use.

Lettering
SIMPLE PHRASE

A simple phrase like Hello Friend, Happy Birthday or Congratulations is great for the front of a greeting card or a gift tag. This is also the best place to start experimenting with lettering techniques. Use straight lines as a guide for the letters and add small details to the colored portion of the phrase. Refer to the full alphabet on page 106 for reference.

1 Block In the Letters
Lettering should be the first thing on your page. Choose a short phrase, and in the center of your paper write large capital letters with a black permanent marker. Use a ruler to align the words if needed.

2 Thicken One Side of the Letters
Make one side of the letters a bit thicker including the outer curve of the rounded O.

3 Add a Thin 3-D Line
Add a thin line next to the thickest line of the letter leaving a little bit of a gap in between.

4 Color the Letter
Color or shade the gap and add a simple zigzag filler pattern using a fine-tipped pen.

Lettering
LONG QUOTE

Long quotes are a great addition for scrapbooking, or I like to use them for wall art. Using the straight line method previously described can be a little too simplistic for some memorable quotes. Using the alphabet on page 106 as a guide, create a quote on a wavy line to add visual interest to longer quotes.

1 Select a Quote
Write out a quote or longer sentiment on scrap paper and circle the words that are most meaningful.

2 Practice Sketching the Letters
Create a wavy line design in the direction you want the words to go. Make the gaps larger where the circled words are going to be to give them the most importance. This may take several tries, so a light pencil stroke will allow for easy erasing.

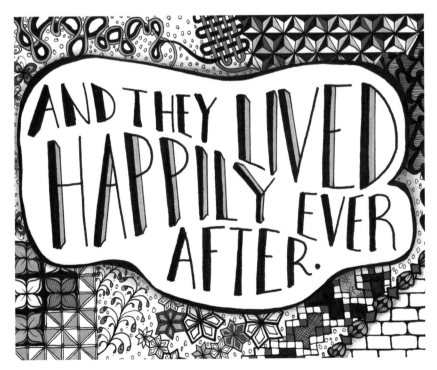

3 Trace the Line and Add Patterns and Color
When you are satisfied that the phrase looks good in pencil, copy it with a black permanent marker and make one side of each letter a little thicker. Finally, add the extra line, color and filler pattern to the meaningful words.

Visit createmixedmedia.com/zen-doodle-unleashed to download free bonus materials.

103

Lettering
STENCILS

Adding lettering with a stencil is best for a single letter or word. Choose a stencil with a very open design. If you decide to add a background to your patterned stencil, create contrast by coloring or shading the background opposite of the letter. So if your letter is colored, use a black-and-white background and vice versa.

1 Lightly Trace the Letter
Using a light touch, trace a stencilled letter with a pencil. The pencil lines will later be erased, allowing the pattern and color to be the focus rather than the harsh edge a pen would create.

2 Draw a Grid Within the Letter
Draw a light gridline in the stencilled letter. I prefer a single gridline pattern for stencilled letters because it's more structured and looks nice within the defined area.

3 Draw the Pattern
Draw a pattern inside the letter. Here I chose a LiLi pattern (see page 81) and used an 08 pen.

4 Add Color, Shading and a Background

Once the letter is filled with a pattern, decide whether the letter or the background will be in color. Here I chose orange and yellow permanent markers for the letter, then added thin vertical lines using an 01 multiliner for a filler element within the LiLi pattern. I also added a background around the letter of Bricks and Leafing patterns with a bit of shading. Don't forget to add a bit of shading around the letter for added depth.

Visit createmixedmedia.com/zen-doodle-unleashed to download free bonus materials.

105

ALPHabet

Use this guide to help you know where to place the thicker lines and colored portions of the letters. When creating a longer quote on a wavy line, remember that these basic letters will stretch to fit within the lines, but the general shape and shading will remain the same.

I believe in the person I want to become.

−Lana Del Rey

Create a Freeform Tangle Quote

My favorite way of using lettering is to feature quotes that inspire me such as the Lana Del Rey quote in this piece. When you are ready to experiment with different fonts, try looking online for free font downloads and duplicating them. In this quote art, I used a free font called Channel.

Visit createmixedmedia.com/zen-doodle-unleashed to download free bonus materials.

107

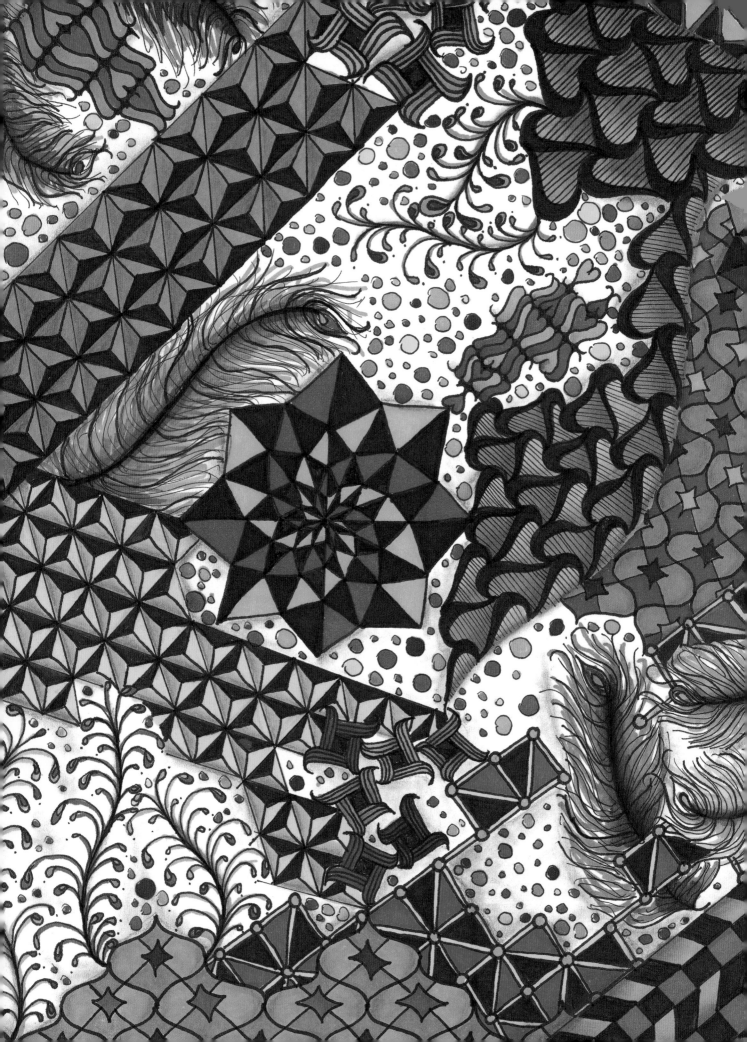

11

TIPS & TEMPLATES

Over the years of being online and sharing my artwork on YouTube and other social networking sites, I've been asked countless times for advice for the beginner. In this chapter I've put together a list of useful tips and tricks to help you overcome some common problems you may encounter when creating freeform tangles.

One of the most useful tips I have found is to practice patterns within spaces that are not conventional shapes. I've learned that extending a pattern off the page or overlapping one with another can sometimes feel unnatural—it feels strange to end a design without finishing it completely. In this chapter I have also included five templates starting on page 112 to help you practice the patterns you've learned. This will allow you to work on ending patterns mid-step, which is very important in freeform tangle art.

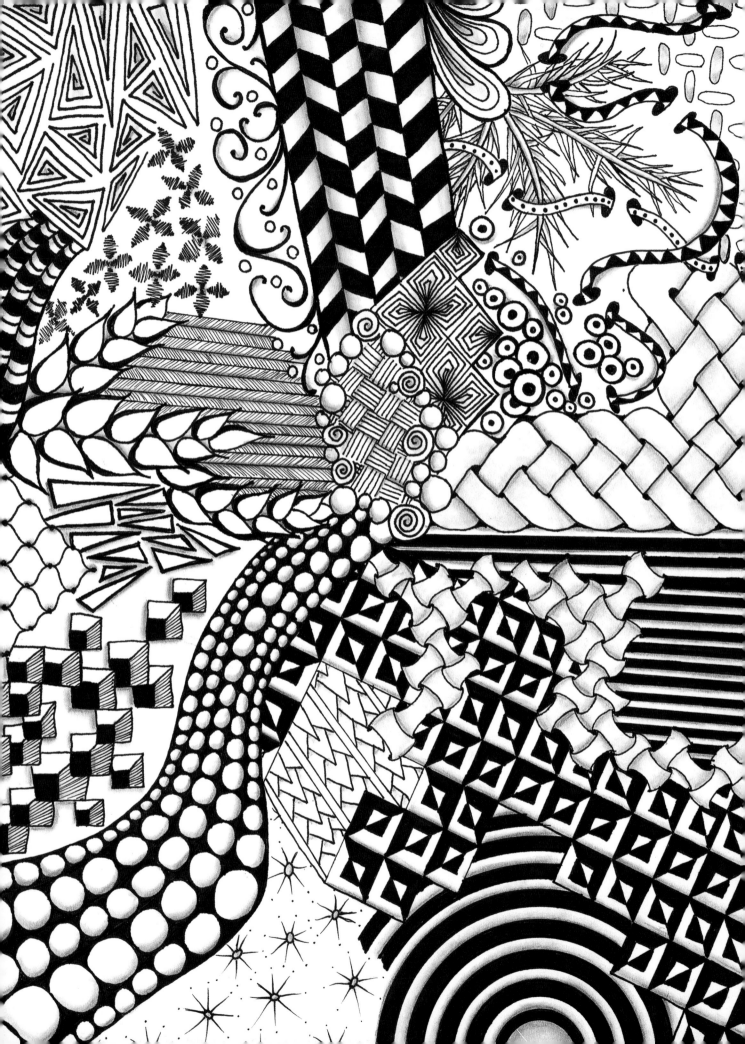

Tiffany's Top Ten Tips

1. When learning a new pattern, start off by creating it much larger than what you would naturally use in a drawing. This will allow you to finish the pattern with whatever details are needed. It can be frustrating to try a new pattern and not have enough space to add the last step. Once you have the steps figured out, you will be able to create it on a smaller scale.

2. Start with small freeform tangle drawings. It can take a very long time to draw an 8" × 10" (20cm × 25cm) tangle. When starting out with this type of art, it's best to work in a smaller area like 3" × 3" (8cm × 8cm) and eventually work up to making larger, more detailed pieces.

3. When you don't know where to start, just pick any pattern and put it anywhere on your paper. The important thing is to draw something. There's nothing less inspiring than staring at a blank sheet of paper. Once you have something down, you might feel inspired to continue with a particular pattern, but if you don't, simply choose another pattern. It will feel forced and unnatural, but once you have a few patterns drawn, you should start feeling the creativity flow.

4. Switch the size of multiliner pens you're working with often. Using the same size multiliner pen can cause a drawing to look flat. It's rare that this flat look is the effect you want, so if you've been holding the same pen for a while, it's time to switch and see how changing the pen can add some beautiful dimension to your drawing.

5. You will feel artist's block at some point, it's only natural. This is the perfect time to try something new. I have discovered that artist's block is just having the idea of perfection in your head. If you try something new, you're not going to be perfect at it, so it breaks the idea of perfection.

6. Look for patterns in the world around you. Sometimes seeing a pattern on a shirt or the texture of tree bark can be incredibly inspiring. It might be easier to look up patterns on your computer, but being able to touch a pattern physically is much more inspiring.

7. Don't be too hard on yourself. It's so easy to look at what you're doing and think it's awful. Instead of throwing it away or putting yourself down, figure out a way to inprove the piece. It is very satisfying when you aren't happy with a piece that's half done and it becomes your best work. Even if it doesn't become your best work and you're still not happy with the result, think of it as a learning tool and don't become discouraged.

8. Get a box or album to keep your finished drawings in and keep them for a long time. It is quite fun to look back on what you did at the beginning and compare those pieces to what you're doing just a few months later. You will see an improvement and feel encouraged to keep going.

9. Join a group. There are a ton of wonderful doodle, drawing, tangle and other art groups offered online and in the community. Find at least one to become involved with. It's a great resource for new ideas, and it's a great place to receive some encouragement when you're feeling like you need it.

10. Find your own style through experimentation. After learning the basics of how to create a freeform tangle, try experimenting with what you know. Add variations, work with different supplies and change the way the patterns are placed on the page to lead you to discover your own style.

112

101 Patterns by Tiffany Lovering

One of the best resources I have is a booklet of different patterns that I can use to as a quick reference. With so many patterns available, it's easy to forget the ones you don't use as often. Cut out and staple together this pattern booklet to keep with you when you draw. You just never know when you might need a quick idea for a pattern or filler!

53 Go-to Patterns

Tri-Inside

Crossword

Splash

Zig Zag

Esses

Peek-a-Boo (Circles)

Peek-a-Boo (Triangles)

Peek-a-Boo (Combo)

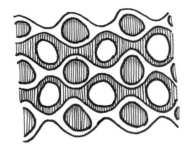

Dottie

Alli

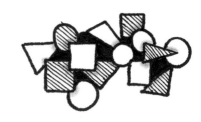

Overlapped

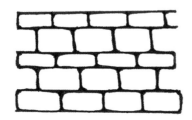

Bricks (Horizontal)

Bricks (Round)

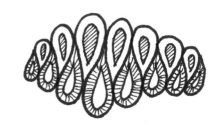

Raindrops

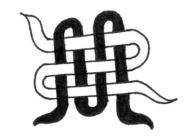

Woven

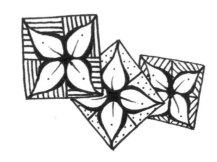

Flower Windows

Swooshy Squares

Daisy Diamonds

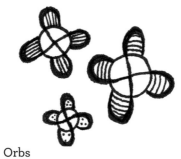

Orbs

Round-a-Pole

8 Flowers

Zig Zag Border

Noodle-O's

Tangled

Flower Chain

Diamond Stripes

Flipsy Flopsy

Center Wave

Drop Flower

Connected

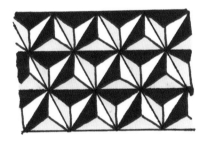

Tri-Star

Skippy

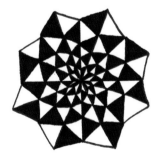

Geo Flower

Flower Lines

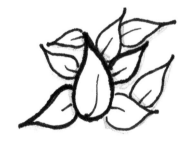

Lots of Petals

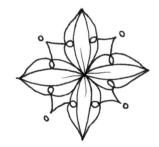

Bloomin'

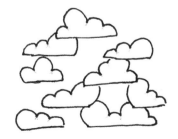

Clouds

Leafing

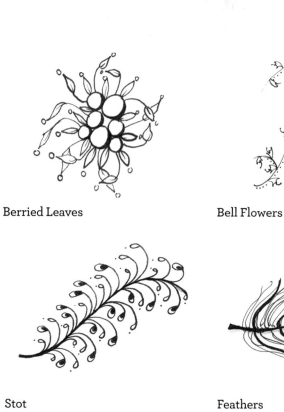

Berried Leaves

Bell Flowers

Asparagus Tops

Stot

Feathers

Flower Windows (Gridline)

XO

Cornered

Exes

Houndstooth

Toom

Gems

LiLi

Hex-an-X

Squircle

40 Filler Patterns

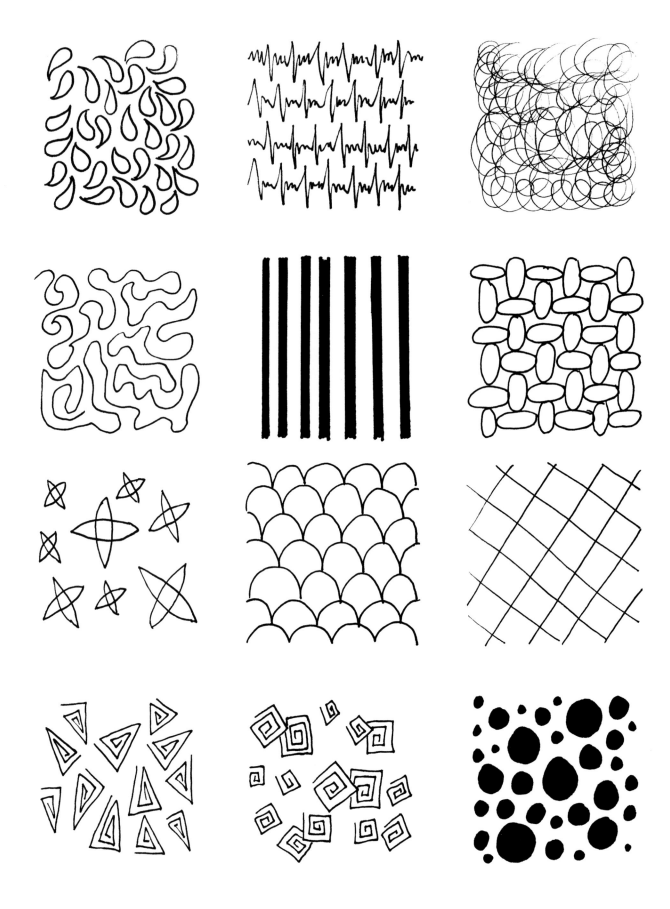

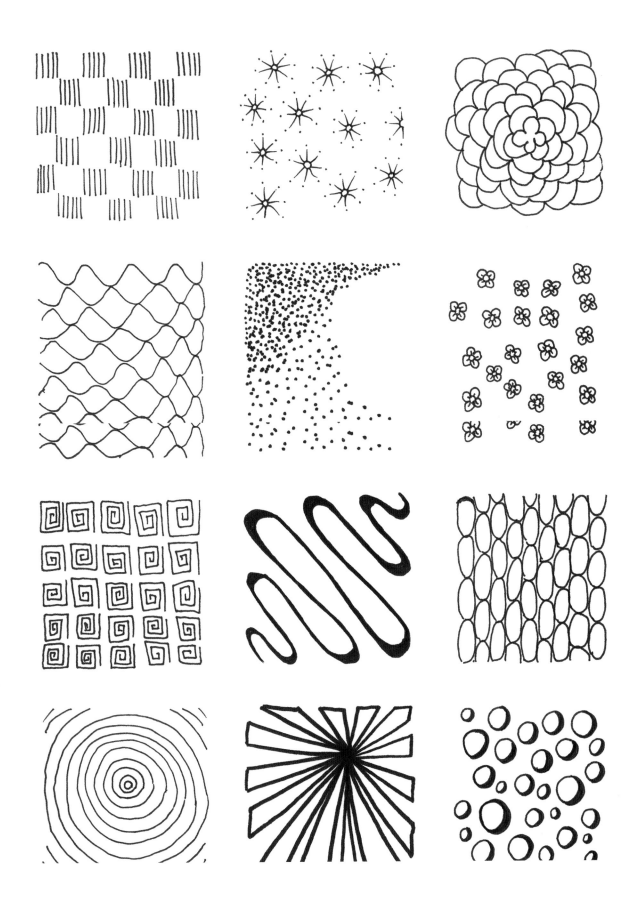

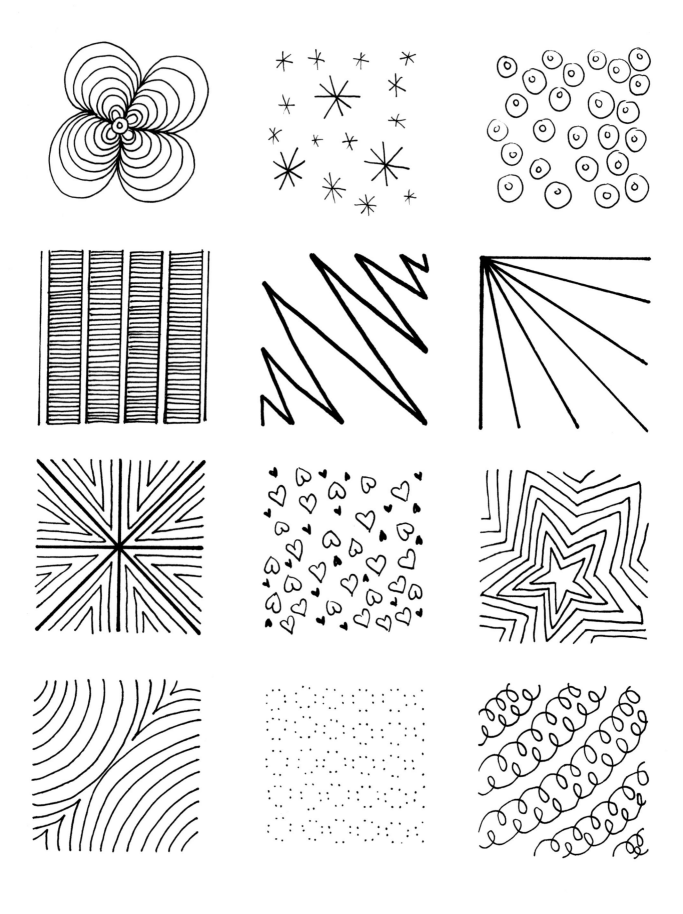

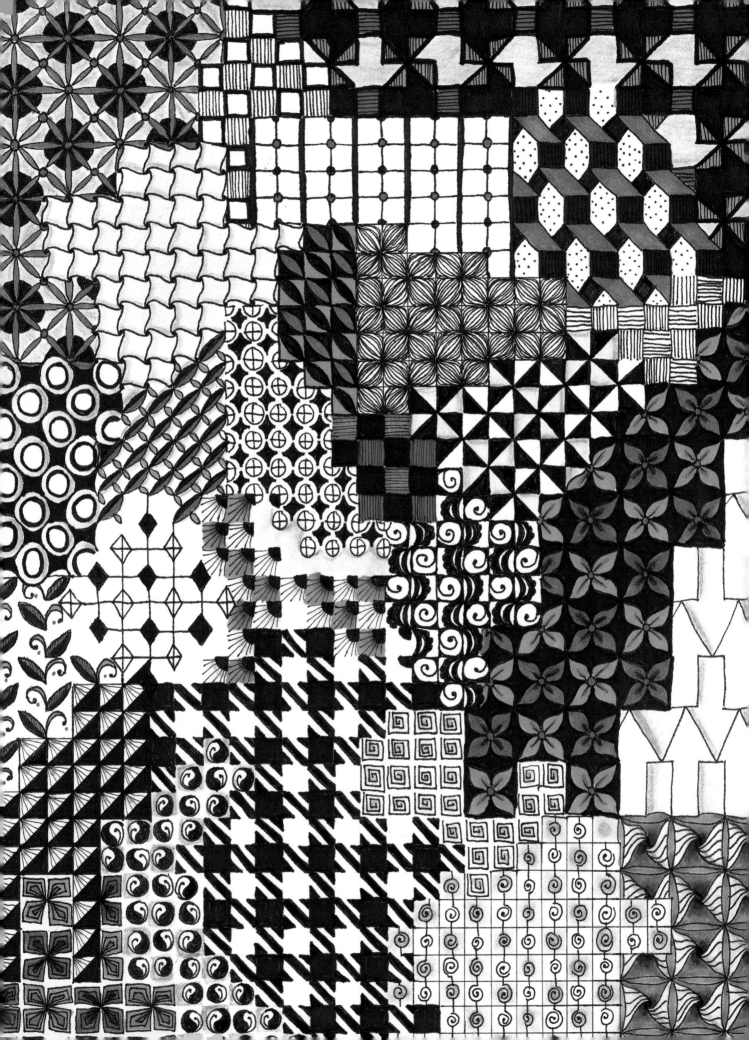

INDEX

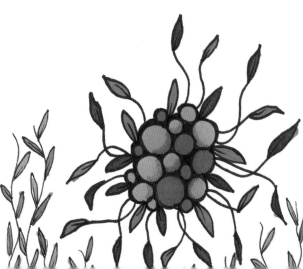

CONNECT WITH TIFFANY!

 youtube.com/tiffanylovering

BLOG: tiffanytangles.blogspot.com

 facebook.com/TiffanyTangles

twitter.com/tiffanylovering

Zen Doodle Unleashed. Copyright © 2015 by Tiffany Lovering. Manufactured in China. All rights reserved. No part of this book may be reproduced in any form or by any electronic or mechanical means including information storage and retrieval systems without permission in writing from the publisher, except by a reviewer who may quote brief passages in a review. Published by North Light Books, an imprint of F+W, A Content and eCommerce Company, 10151 Carver Road, Suite 200, Blue Ash, Ohio, 45242. (800) 289-0963. First Edition.

a content + ecommerce company

Other fine North Light Books are available from your favorite bookstore, art supply store or online supplier. Visit our website at fwcommunity.com.

19 18 17 16 15 5 4 3 2 1

DISTRIBUTED IN CANADA BY FRASER DIRECT
100 Armstrong Avenue
Georgetown, ON, Canada L7G 5S4
Tel: (905) 877-4411

DISTRIBUTED IN THE U.K. AND EUROPE
BY F&W MEDIA INTERNATIONAL, LTD
Brunel House, Forde Close, Newton Abbot, TQ12 4PU, UK
Tel: (+44) 1626 323200, Fax: (+44) 1626 323319
Email: enquiries@fwmedia.com

DISTRIBUTED IN AUSTRALIA BY CAPRICORN LINK
P.O. Box 704, S. Windsor NSW, 2756 Australia
Tel: (02) 4560-1600; Fax: (02) 4577 5288
Email: books@capricornlink.com.au

ISBN 13: 978-1-4403-4270-7

Edited by Sarah Laichas
Designed by Corrie Schaffeld
Production and cover design by Elyse Schwanke
Production coordinated by Jennifer Bass

About the Author

Tiffany Lovering started tangling as a fun and relaxing craft in between writing novels. As she learned the art of creating different patterns and techniques, tangling quickly became a passion she wanted to share with others.

In 2013 she created a YouTube channel dedicated to showing others her tangling techniques. She has since amassed more than 400 videos, 45,000 subscribers and 4 million views (and going strong!). In addition to YouTube, she has created a small Facebook community where fans can participate in a monthly tangle swap. She writes a blog discussing her inspiration and the processes of her more popular tangles.

Tiffany also has produced three North Light DVDs that cover tangle tips, techniques and patterns. She also teaches several online courses on tangling and mandalas throughout the year.

In addition to the art of tangling, Tiffany is passionate about reading and has a book review blog. She currently has four novels and one short story available on Amazon. She resides in Tennessee with her daughter, Allison.

Dedication

To my YouTube subscribers who continue to keep me inspired to try new things and who encourage me to share my artwork. To my daughter, Alli, for her endless supply of coffee as I create my artwork and for being my best cheerleader when I need it most.

Acknowledgments

A very special thank you to my wonderful editor, Sarah Laichas, for her patience and hard work on this book. Also to Tonia Jenny and Mona Clough who first approached me and helped pave the way for my amazing North Light experience.